SOUTHEND SEASIDE

THROUGH TIME

Michael Rouse

AMBERLEY PUBLISHING

For Max and the Sherringhams of Southend and for Phil
– you can take the girl out of Essex, but...

M. H. R.

First published 2013

Amberley Publishing
The Hill, Stroud, Gloucestershire, GL5 4EP
www.amberley-books.com

Copyright © Michael Rouse, 2013

The right of Michael Rouse to be identified as the
Author of this work has been asserted in accordance with
the Copyrights, Designs and Patents Act 1988.

ISBN 978 1 4456 0001 7

British Library Cataloguing in Publication Data.
A catalogue record for this book is available from the
British Library.

Typesetting by Amberley Publishing.
Printed in Great Britain.

Introduction

I love Southend; I love its brashness and vulgarity; I love its elegance and history. My late father would tell me of the wonders of going to the Kursaal in its heyday between the wars and my wife's mother lived in Southend and her mother worked as a waitress at a restaurant on the seafront.

This volume takes a tour of some 8 miles along the seafront from the ancient port and small fishing village of Leigh-on-Sea, known for its shellfish and whitebait, to Chalkwell, Westcliff-on-Sea and through Southend to Thorpe Bay and Shoeburyness. The emphasis is on the holiday industry and the people who enjoyed the precious, long-awaited, never to be forgotten few days at the seaside.

In around 1895 a little boy, his older brother and their mother, through a stroke of good fortune, were able to afford a holiday at Southend and for the first time escape the poverty of London: 'My first sight of the sea was hypnotic. As I approached it in bright sunlight from a hilly street, it looked suspended, a live quivering monster about to fall on me. The three of us took off our shoes and paddled. The tepid sea unfurling over my insteps and around my ankles and the soft yielding sand under my feet were a revelation of delight.

'What a day that was – the saffron beach, with its pink and blue pails and wooden spades, its coloured tents and umbrellas, and sailing boats hurtling gaily over the laughing little waves, and up on the beach other boats resting idly on their sides smelling of seaweed and tar – the memory of it stills lingers with enchantment.'

The boy was Charles Chaplin and he probably spoke for so many of his fellow Londoners and trippers recalling the magic of that first trip to the 'Cockney Paradise'.

Southend is famous for its pier, the longest in the world at 1⅓ miles in length, and no visit to the resort is complete without going on the pier, but there have been occasions when I have not found it possible, as it has been a very accident prone structure. After all, Southend is at the mouth of the River Thames and the pier projects into what are very busy coastal waters.

Another thing that no trip would be complete without is at least one genuine Rossi's ice cream cone. Rossi have been famous for their ice creams in the resort since 1932.

Southend has seen some hard times as the English seaside struggled in the face of cheap foreign holidays in the sun. At the turn of the twentieth century the town council was ambitious and shaped the modern resort. Now, a hundred years or more later, there is a sense that the

modern council realises what an important heritage they have to develop going forward and there has been considerable, welcome investment in both the shopping and the seafront. This has made Southend and its neighbours one of the most attractive places in the country in which to live and, of course, to visit.

Michael Rouse
Ely, 2013

Acknowledgements

I have collected numerous books on Southend and its neighbours over the years, since I wrote *Coastal Resorts of East Anglia, the Early Days* for Terence Dalton in 1982. I have referred to *Southend Seaside Holiday*, Sylvia Everitt (Phillimore, 1980); *The Story of Southend Pier*, E. W. Shepherd (Egon, 1979); *Southend-on-Sea Past and Present*, Ken Crowe (Sutton, 2000); *Southend-on-Sea Then & Now*, Ken Crowe (History Press, 2011); *A History of Southend*, Ian Yearsley (Phillimore, 2001, reprinted 2010) and *Southend Through Time*, David C. Rayment (Amberley 2011). I have used a Town Guide published in 1925 and searched various websites.

In 1991, Cyril Braysher Pearse was kind enough to send me some of his memories of Southend and I have quoted from them.

My thanks to my older daughter Lauren and my younger son, Lee, who came with me to take some photographs on a scorching Sunday in July this year and Lauren certainly took the two photographs of Shoeburyness (91 & 92). She may be responsible for one or two others, but I'm not admitting to those. All my photographs were taken in July this year (2013) except 3, 6, 10, 11, 38, 40, 41, 75 (inset) and 90, which were taken in early September 2011, and 72 (inset) is from *c.* 1980.

My thanks to smiling young ladies selling the best ice cream in the world, the friendly hard-working waitresses in the Neptune Fish Restaurant and to all those I meet on my travels and answer my questions.

Finally, my thanks to Joe Pettican and all at Amberley who encourage me to revisit some of my favourite places.

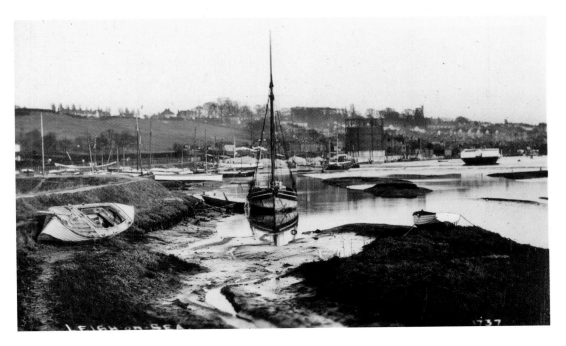

Leigh-on-Sea, *c.* 1912

The problem with beginning any trip along the coast from Leigh-on-Sea to Shoeburyness is that, after having discovered the charms of Leigh, if you didn't already know them, you might not want to leave. During Tudor times, when Henry VIII supported the building of ships of 100 tons or more that could be used for war, a policy that was continued by Elizabeth I, Leigh developed a shipbuilding industry.

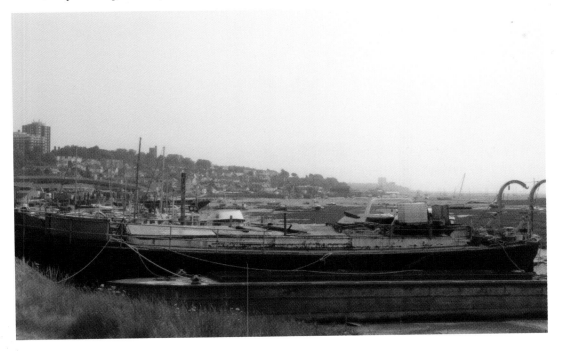

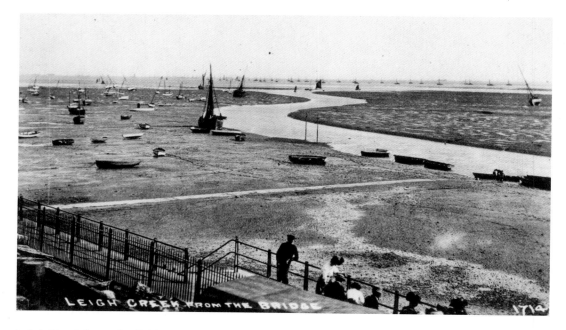

Leigh Creek from the Bridge, *c.* 1912

In 1565, the Examiner of Customs at Harwich reported: 'Leigh is a very proper town, well furnished with good mariners, where commonly tall ships do ride, which town is a common and special landing place for butter, all manner of grains and other things.' At that time Leigh had 31 vessels, 32 masters and owners and 230 mariners and fishermen. In 1652, during the war against the Dutch, Admiral Blake brought ships from his heavily damaged fleet to Leigh for refitting. When Blake sailed from the Thames later that year to defeat the Dutch he commanded sixty men-of-war.

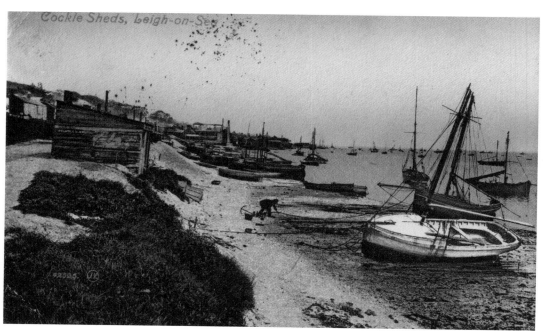

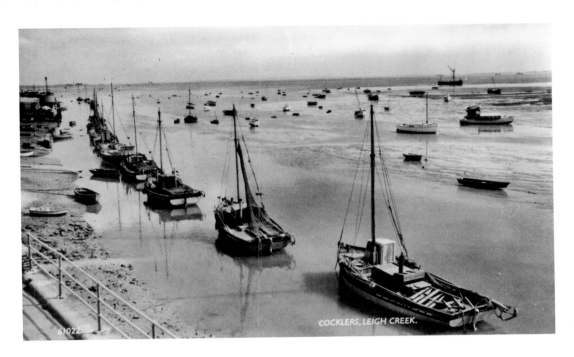

COCKLERS, LEIGH CREEK.

61022

Cocklers, Leigh Creek

In the eighteenth century, the Creek began silting up and the great shipbuilding days were over. Leigh became once more a small fishing village. In 1714, William Hutton, a Leigh fisherman, began the extensive cultivation of oysters, which before then had been gathered from natural beds. Around 1830 shrimping became a major local industry and there were seven or eight 'boiler houses' in the town. In 1872 there were some 100 vessels used in the shrimping industry. Whitebait fishing also became popular from around 1860.

OY MICHAEL
LONDON

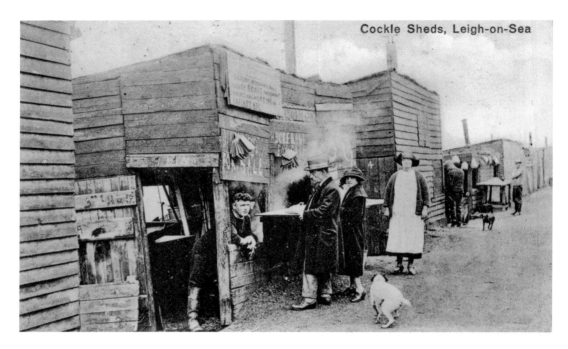

Cockle Sheds, Leigh-on-Sea

Cockle Sheds, Leigh, 1926

The nineteenth-century cockle sheds are a feature of Leigh. The Osbornes are one of the best-known local fishing families, with a business that was established in 1880. At the time of the evacuation of Dunkirk in 1940 the Osborne's boat, *Renown*, was one of six Leigh cocklers that saved lives, but struck a mine on the return with the loss of Frank Osborne, Leslie (Lukie) Osborne, Harry Noakes and Harold Graham Porter. *Endeavour*, one of those 'little ships', has now been restored and since 2005 has been moored at Leigh.

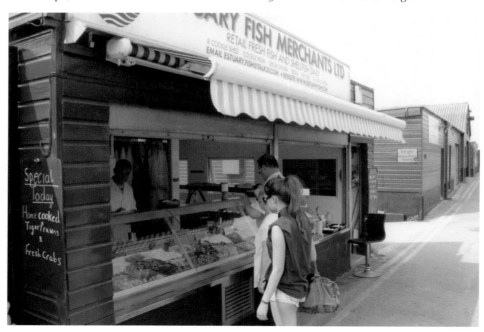

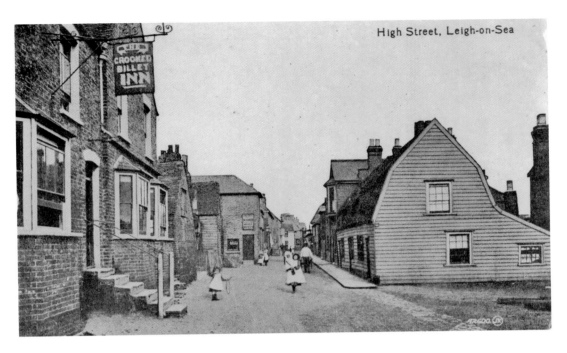

High Street, Leigh-on-Sea, *c. 1908*
The Crooked Billet public house dates from the early sixteenth century and at one time was run by members of the Osborne family. In 1853, the Billet Club was founded at the pub. Its official name was the United Brethren and it was established to help sick fishermen. Membership was restricted to those living within a mile radius. Leigh is well served by public houses and is a busy and popular place with very much its own character.

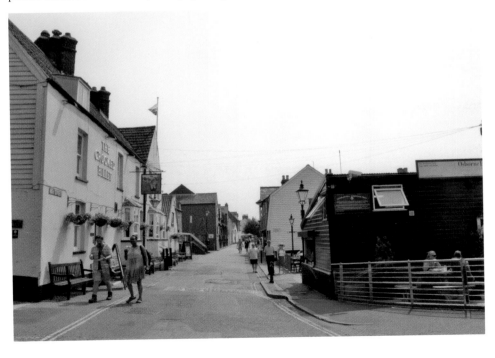

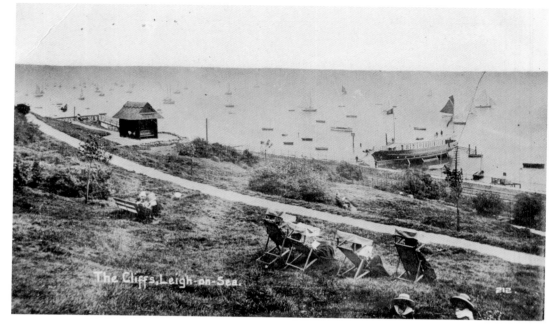

The Cliffs, Leigh-on-Sea, c. 1916

The Cliffs give a wonderful panorama of the Thames Estuary. The London to Southend railway came through Leigh in 1854, causing the loss of many old buildings, but giving the fishermen better access to Billingsgate Market. The line, now electrified, can be seen at the foot of the cliffs. The Essex Yacht Club was founded in 1890 and from 1894 used the *Gypsy* as its headquarters. The Marine Parade area of some 63 acres was laid out in 1908.

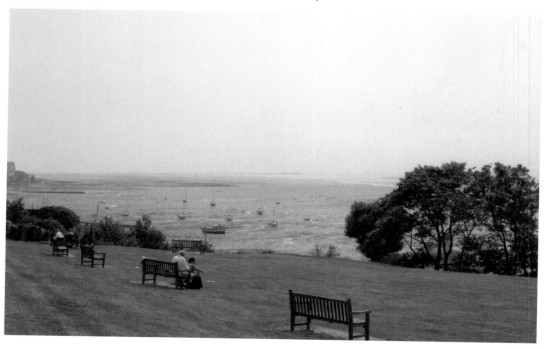

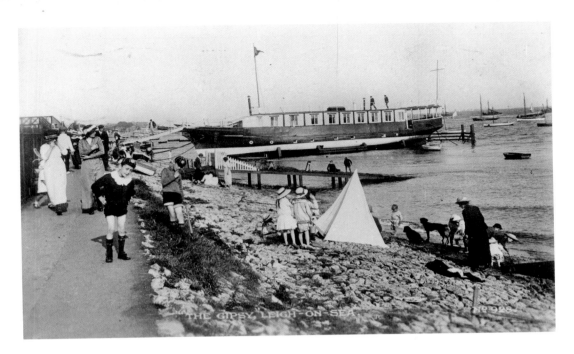

The *Gypsy*, Leigh-on-Sea, *c.* 1920

The *Gypsy* was the floating home of the Essex Yacht Club from 1894 to 1930. She was followed by the *Carlotta* until 1941, then the *Lady Savile* (1947–75) and the *Bembridge* (1975–2004). Today's boat is perhaps the most unusual, being a converted Royal Navy minesweeper, the HMS *Wilton*. Its fibreglass construction hopefully means that it will be a feature of the shoreline for many years to come. The Essex Yacht Club is very active and rightly proud of its strong cadet section.

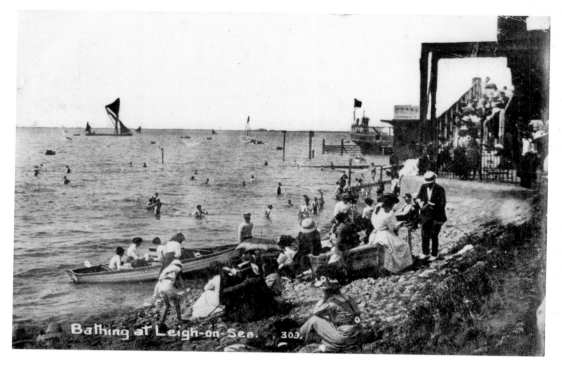

Bathing at Leigh-on-Sea, *c. 1923*

'We are having a lovely time here. Weather delightful.' The simple pleasure of a paddle in the sea has been an essential part of any trip to the seaside and Leigh, with plenty of facilities nearby, has always been a popular spot for both paddling and bathing.

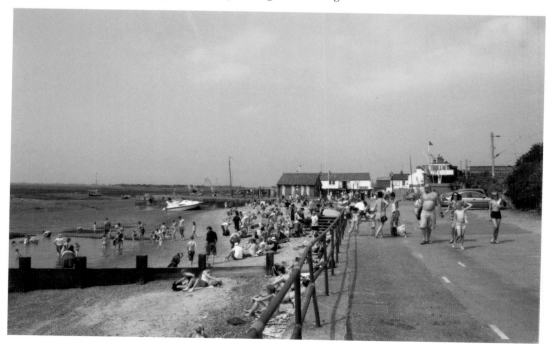

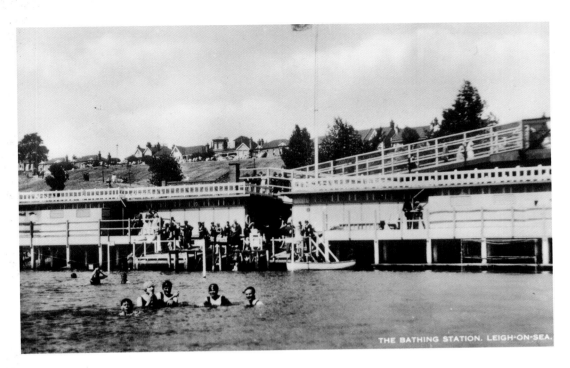

THE BATHING STATION. LEIGH-ON-SEA.

The Bathing Place, Leigh-on-Sea, *c.* 1935

During the 1930s there was a grand bathing station where the bridge from the cliffs crossed the railway line. It survived until 1970 when it was demolished leaving just the modest, but welcome and very popular, paddling place. The elegant curving bridge is a modern structure replacing the earlier one over the railway line.

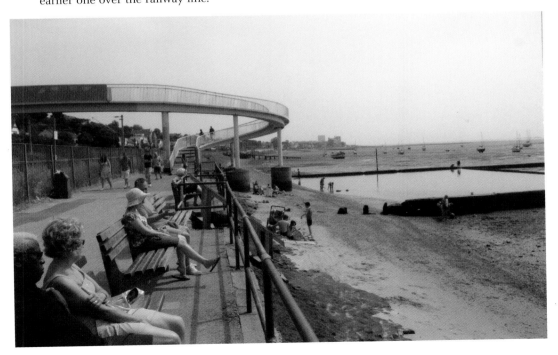

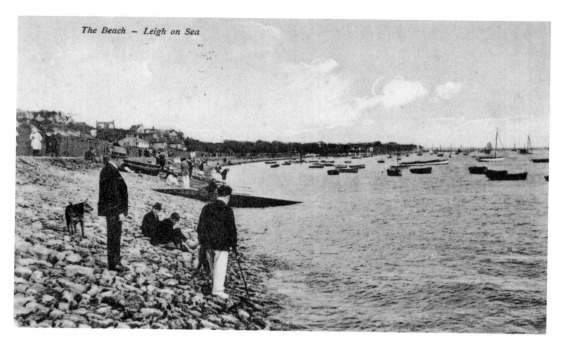

The Beach – Leigh on Sea

The Beach, Leigh-on-Sea, c. 1925

'We are having a lovely time here, it is very warm and dry.' A simple message to friends and neighbours, this one sent in September 1925 to Berkshire, just to tell them that those few precious days at the sea were doing you the world of good. And they were. That is the benefit of the change of scene, the fresh air, the chance to relax. And a postcard sent for one penny would almost certainly arrive the next day.

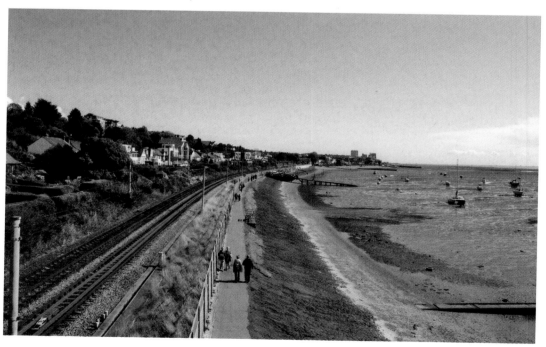

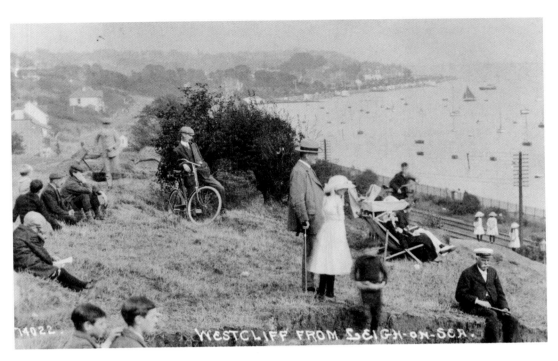

Westcliff from Leigh-on-Sea, *c.* 1913
An absolutely wonderful photograph of that last summer or so before the First World War. Perhaps they are looking at a regatta or even naval exercise, but in this one photograph there is a whole cast of characters for a novel.

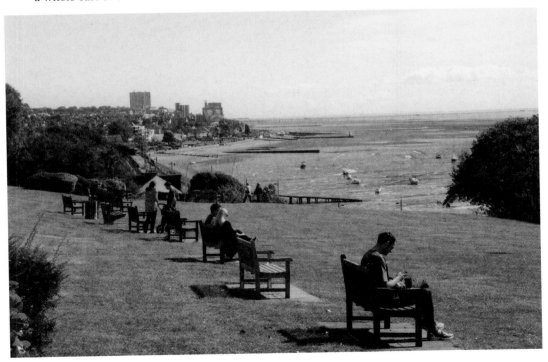

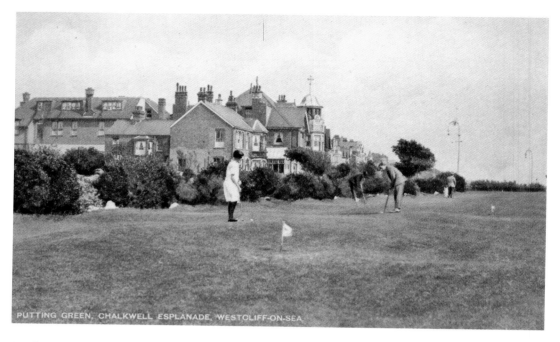

Putting Green, Chalkwell Esplanade, 1920s

What is it about the seaside that suddenly brings on the urge to try and knock a small, hard white ball into a little hole set in a fairly lumpy area of grass? In 1925, the Corporation was advertising its 'interesting 18 hole miniature Golf Course' with use of putter and ball for only *6d* a round. The Chalkwell area developed rapidly after the council acquired the Chalkwell Hall estate in 1901. The development of the Western Esplanade followed from 1904. The Chalkwell area grew even more after the railway station was opened in 1933.

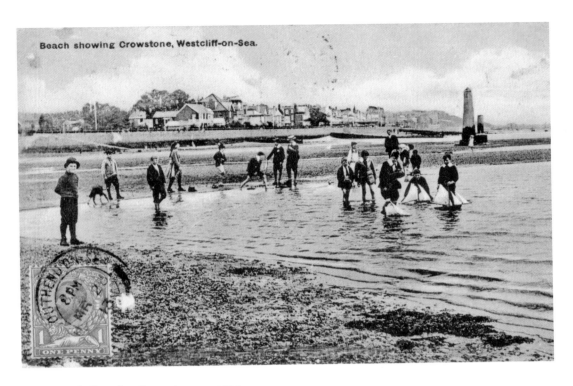

Beach showing Crowstone, Westcliff-on-Sea.

Beach Showing Crowstone, c. 1912
The Crowstone can be seen opposite the end of Chalkwell Avenue and reached at low tide. It was erected in 1837, replacing a smaller stone placed there in 1755 to mark the limit of the Port of London Authority. The original Crowstone is now in Priory Park after it was presented to the Corporation in 1950.

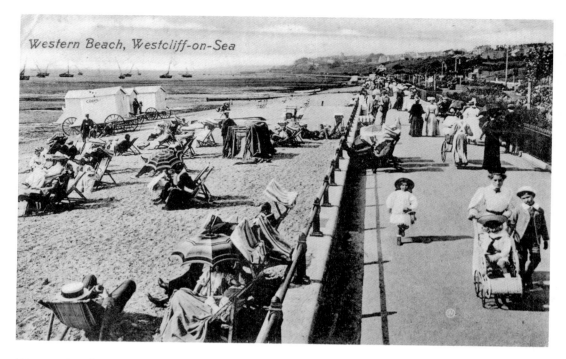

Western Beach, Westcliff-on-Sea

Western Beach, Westcliff-on-Sea, c. 1908

The sea wall was built in 1905 as part of the new esplanade. Three of Davis's bathing machines line the water's edge, a reminder of when the dippers would dip those going to the seaside for the saltwater cure. By the time of these photographs, sea air and the change of scene were seen to be just as beneficial as being immersed in brine. The row of white cubicles now provide changing facilities and there are public toilets and washrooms nearby.

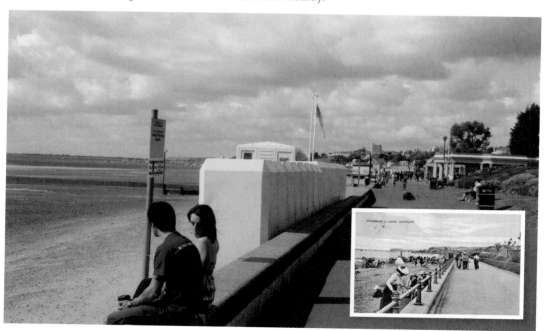

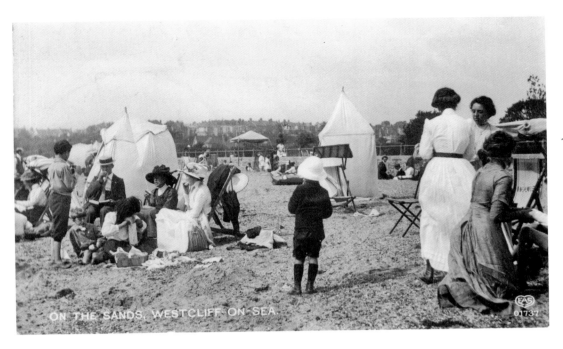

ON THE SANDS, WESTCLIFF-ON-SEA.

On the Sands, Westcliff-on-Sea, *c.* 1913
The wonderful photograph tells its own story – picnicking on the beach among the fluttering small tents, with soggy warm tomato and cheese sandwiches with a dusting of sand – delicious. While many still take a picnic to the beach there are numerous opportunities today to buy a snack or a drink at the many promenade cafés. No visit to Westcliff or Southend would, of course, be complete without one of the famous Rossi's ice creams, which have been such a feature of Southend since the 1930s.

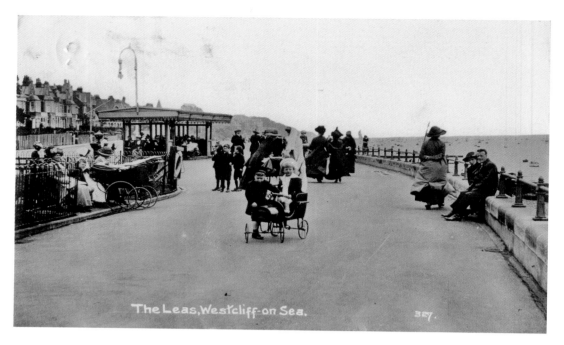

The Leas, Westcliff-on-Sea, c. 1912

Westcliff experienced a housing boom after the railway station opened in 1895. There was some debate over the name, with Kensington on Sea suggested, such were the aspirations of this fine new piece of coast, but Westcliff-on-Sea was adopted. Uniformed nannies and nurses tend their young and, in between walking along the promenade, sit under the shelter or along the front. The young lad in the sailor suit in the foreground has the most marvellous pedal car.

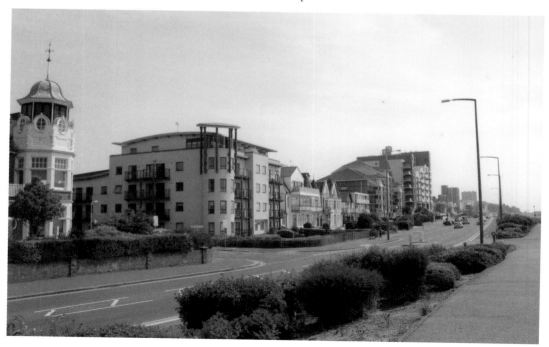

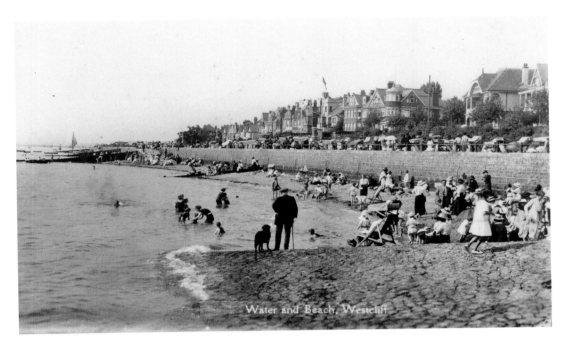

Water and Beach, Westcliff

Water and Beach, Westcliff-on-Sea, *c*. 1920
Westcliff still has a freshness and openness along the stretch towards Chalkwell. This is an area for walking and relaxing, although it can get busy during summer. Because the area developed after the Chalkwell estate was acquired and the new sea wall and promenade were constructed in the early 1900s, public gardens were laid out and the seafront buildings were of a more modest residential scale.

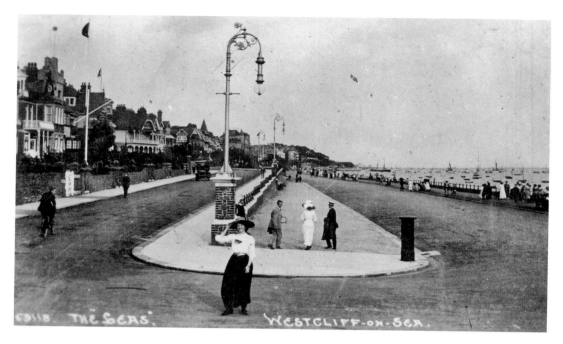

The Leas, Westcliff-on-Sea, *c.* 1918

A photograph showing the position of the flagstaff along the Leas and all the unhurried calm of Edwardian England. Written in September 1919, the card is a story in itself. 'So pleased you are enjoying yourself. Lil and I got back from Westcliff last Friday after a stay of two months. We expect Les Friday or Saturday. He left Cologne on Sunday. Goes to Ripon for demobilisation. Isn't that splendid!'

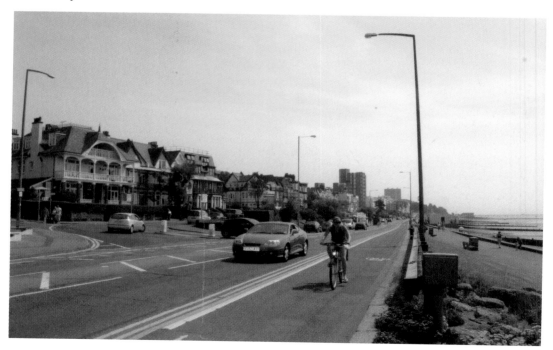

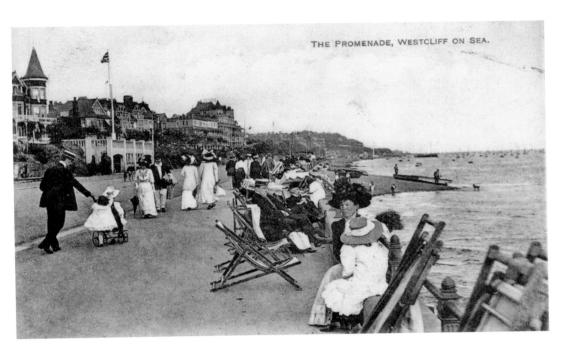

The Promenade, Westcliff-on-Sea, *c.* 1912
'Hope you are well and enjoying holiday. Weather been very fair. It is raining here this morning. Hope to see a bit of flying on Hydoplane. Graham White is to give a show this afternoon. Think I must postpone return until Monday morning.' Claude Graham-White (1879–1959) was an early British aviator qualifying as a pilot in 1910. Robert Williams, who wrote the card, was going to witness a glimpse of the future possibilities of flight.

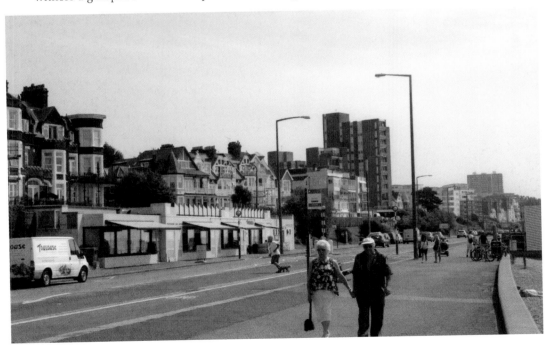

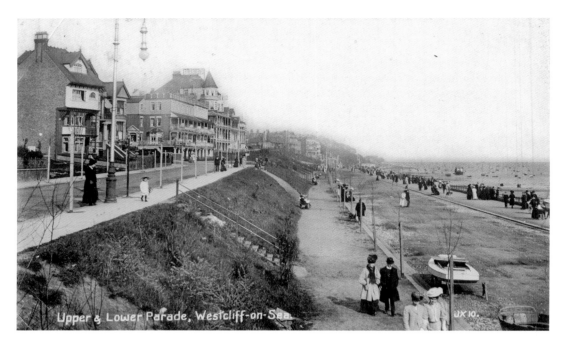

Upper and Lower Parade, Westcliff-on-Sea, *c.* 1908
'I think this promenade would suit you for your morning "Constitutional". When will you come and try? You are very welcome at any time. Come and spend Christmas with us. Lewis.' I do hope Miss Thomas in Birmingham said 'yes'. Who could possibly refuse? The investment of the town council in new promenades and sea walls made Westcliff an elegant and refined place by the sea.

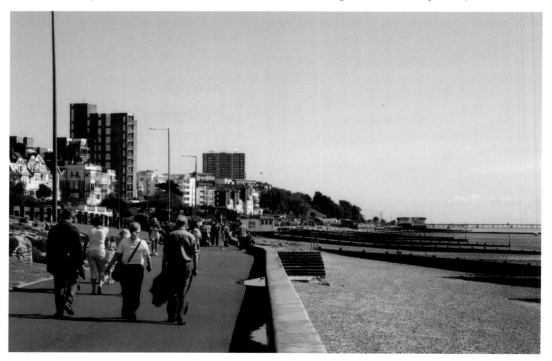

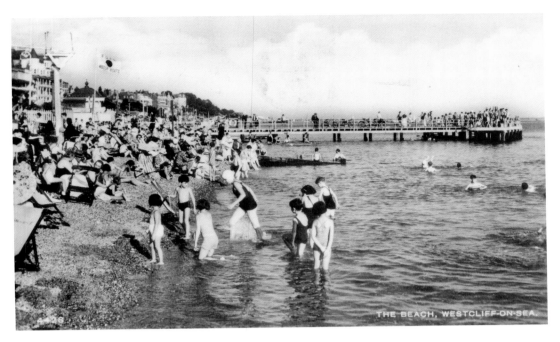

The Beach, *c.* 1938

Westcliff-on-Sea in its heyday between the wars. The motor car has opened the coast for many more people. Crowds wait on the jetty for speedboat rides and the beach is packed. The huge beachfront hotels and the boarding houses would be doing a roaring trade. Even the events in Europe were not casting a shadow over the seaside holiday.

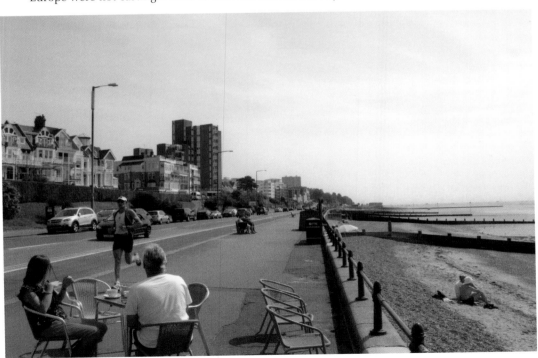

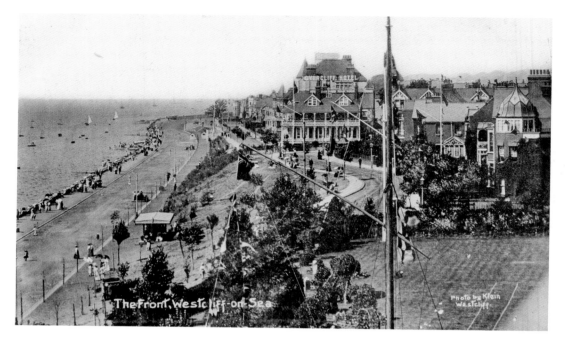

The Front, Westcliff-on-Sea, *c.* 1960

In 1923 the magnificent Overcliff Hotel was added to the seafront attractions. Sadly, the glory days of the English seaside holiday were not to last and such big hotels with their large staff were going to feel the loss of trade the hardest. The Overcliff was another victim of the decline of the English seaside in the 1960s and early 1970s, with the availability of cheap foreign holidays in the sun.

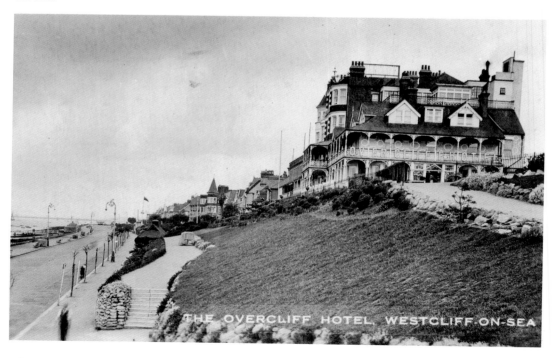

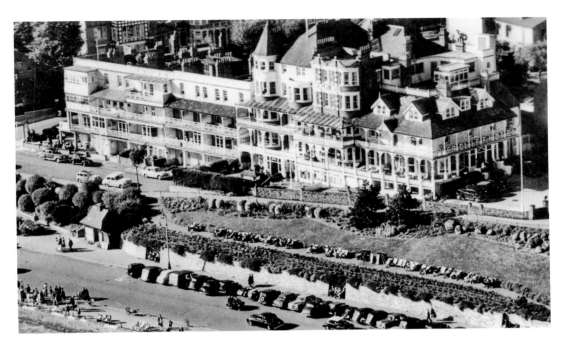

Overcliff Hotel, *c.* 1960
The immense Overcliff Hotel, with its sea-facing balconies, like a huge luxury liner, sadly lasted only around fifty years before it was demolished. Perhaps the replacement flats are what the Reverend Thomas Archer had in mind in his poem, published in 1794, about the new 'South End': 'Here with prophetic view the Bard descries, Streets shall extend and lofty domes arise,/ Till New South End in each spectator's eye,/ With Weymouth, Margate or Brighthelmstone (Brighton) vie.' Or then again, perhaps not.

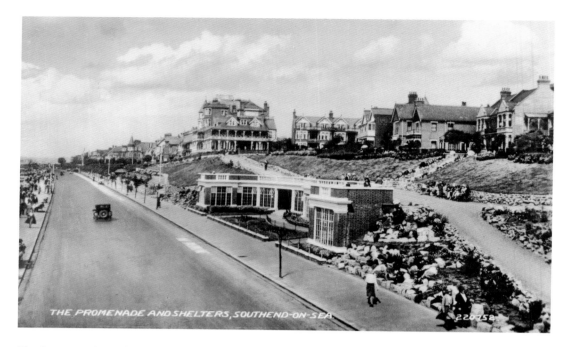

The Promenade and Shelters, *c.* **1935**
A delightful shelter that must date from the 1920s. There was a time when rain or shine seaside landladies did not welcome their guests back to their boarding houses during the day, so sometimes watching the rain lash down and the waves beat against the sea wall from such a shelter helped to make the holiday fly by. Now the sign says that it is 'To Let', giving opportunities for a restaurant or café in what is a splendid position.

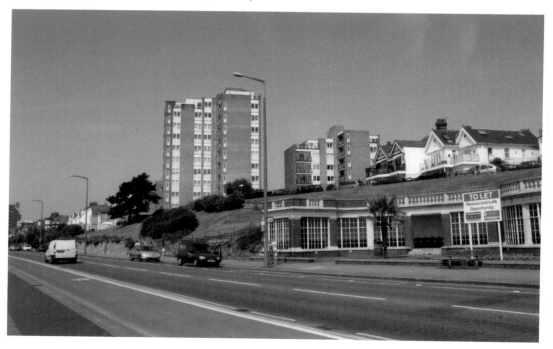

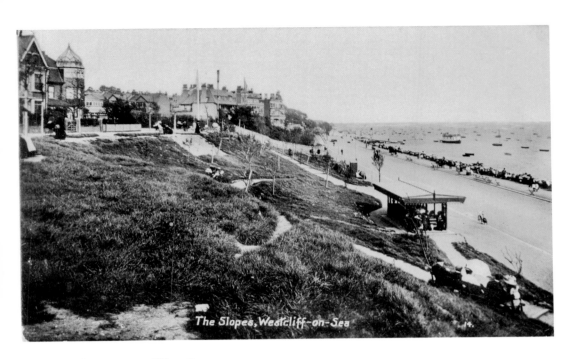

The Slopes, Westcliff-on-Sea, *c.* 1909
'Feel very sorry to return, have had lovely weather.' But Mabel would have to return to Stoke Newington and the smoke and grime of London along with whatever work she had left back there. With luck she would have happy holiday memories to sustain her. The imposing 1930s Art Deco Argyll House apartments can be seen in today's photograph.

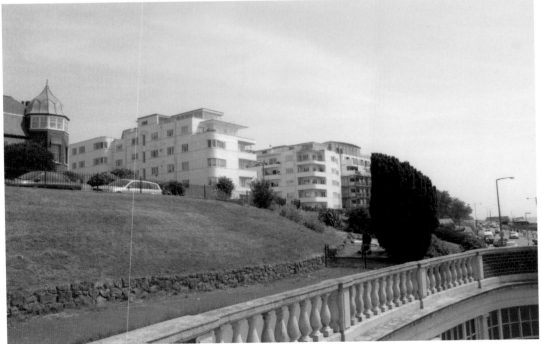

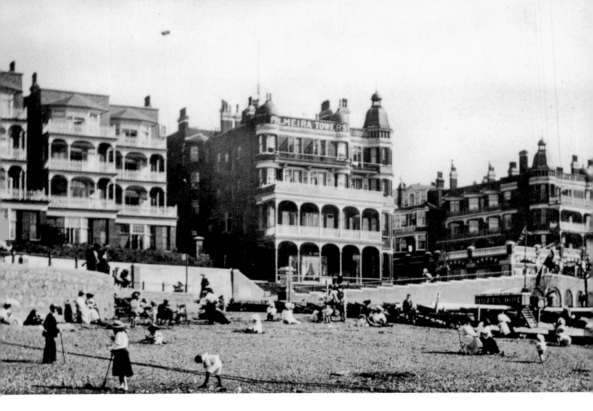

The Beach, Westcliff, *c.* 1908

What confidence in the future to build such impressive hotels! The Palmeira Hotel, designed by J. Edmonson, graced the seafront from around 1900 until it was demolished in 1978 and replaced by flats.

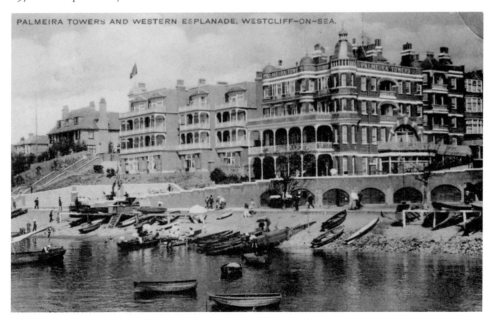

PALMEIRA TOWERS AND WESTERN ESPLANADE, WESTCLIFF-ON-SEA.

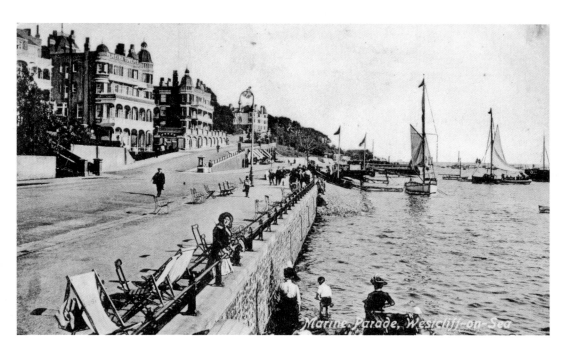

Marine Parade, Westcliff-on-Sea, *c.* 1919

The improvements to the promenade can be clearly seen with the strong sea wall and railings. Many working people never had a holiday. In 1871, Parliament passed the Bank Holidays Act, due mainly to the campaigning of Sir John Lubbock, later the 1st Baron Avebury. Those four bank holidays, principally Whit Monday and August Bank Holiday, were to transform the fortunes of the seaside industry and many people's lives.

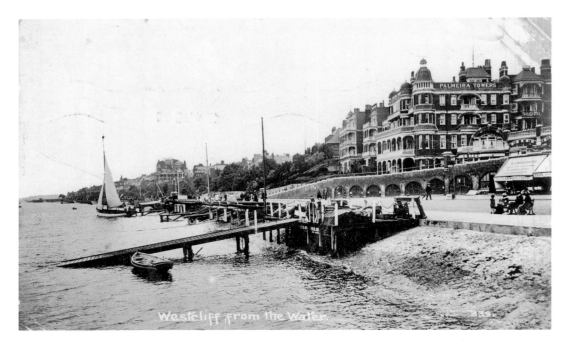

Westcliff from the Water, *c.* 1916

It really was a magnificent place as it developed up until the First World War. There was vision, enterprise and buildings on a grand scale. The Acorn Café in 1925 offered 'Smart Luncheons, Teas and Ices'. It was open until 11 p.m. and there were whist drives, confectionery and beach trays. Mrs Webster, the proprietress, also advertised furnished flats and board residence.

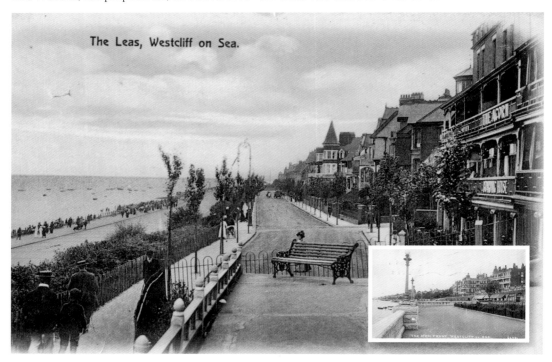

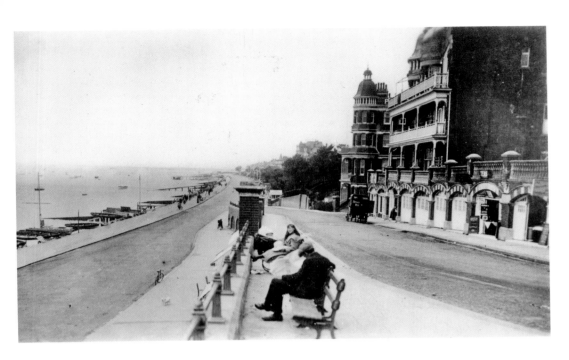

Western Parade, c. 1920
A beautiful but deceptive photograph that misleads the eye into thinking the man, girl and baby in the pram are seated behind the railing at the same level as the pavement in front of them. In fact they are on a higher level altogether above the row of shops. The arches below the Palmeira Hotel were originally coach houses but fortunately they were saved and converted into small shops and cafés.

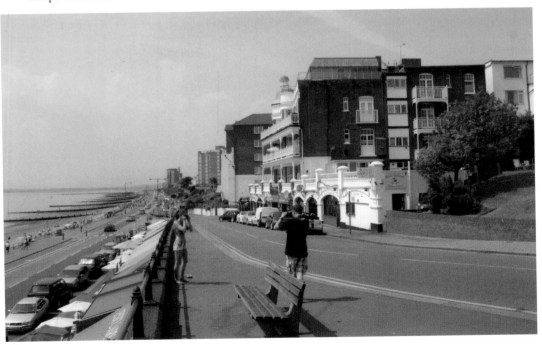

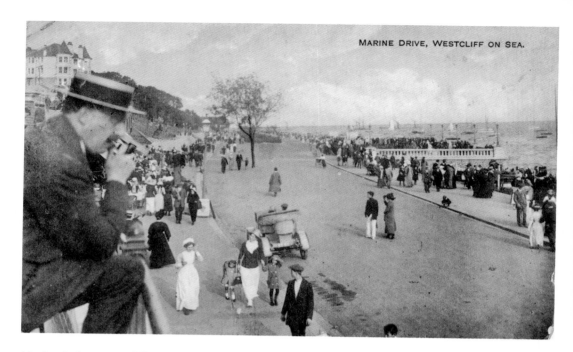

Marine Drive, Westcliff-on-Sea, c. 1913

While the gentleman quietly smokes his pipe and surveys the scene (possibly from the top of the shelter) there is another glimpse of the future in the car on the road below. It was probably impossible then to realise how, in fifty years or less, the motor car would transform this leisurely seafront scene; even more so to imagine that instead of sending a postcard you could be in touch with everyone by mobile phone while enjoying the seaside.

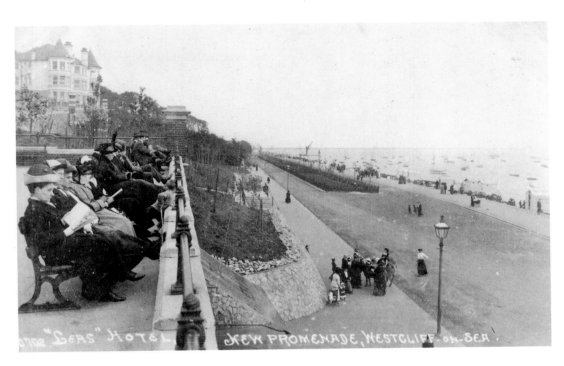

'Leas' Hotel, New Promenade, Westcliff-on-Sea, *c.* 1919
Fashions may change but a seat in the sun above the promenade is still much sought after today.

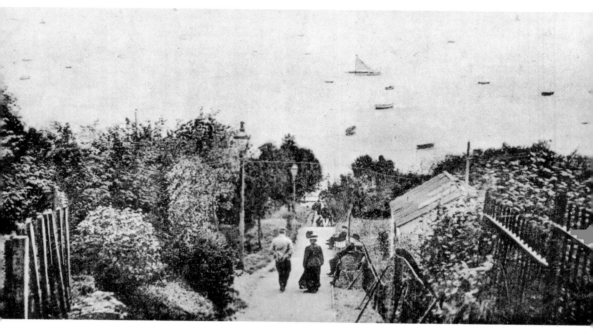

The Cliff Steps, c. 1916

A feature of Westcliff is the number of different sets of steps from the cliffs to the promenade. If I have got the right ones, at the top of these steps it was intended that a new concert hall be built in the 1920s. The council purchased the land at Shorefields for this purpose in the 1930s. The Cliffs Pavilion was eventually opened in 1964.

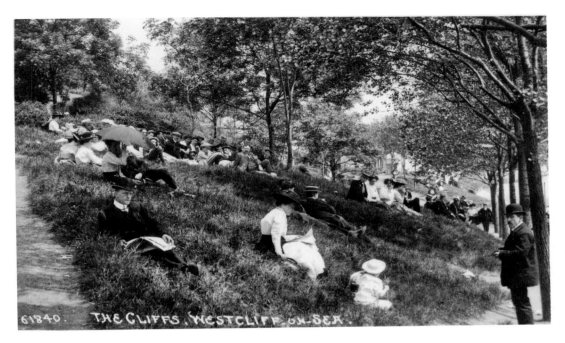

The Cliffs, Westcliff-on-Sea, *c.* 1913
Posted in August 1913 back to Southfields, London SW: 'Dear Pop, Just a card to let you know am down here and having a ripping time. Plenty of tennis and plenty of girls. The photo shows you what nice spots there are here after dark. Geo.' One of the places to take a young lady as dusk fell was to watch one of the many concert parties.

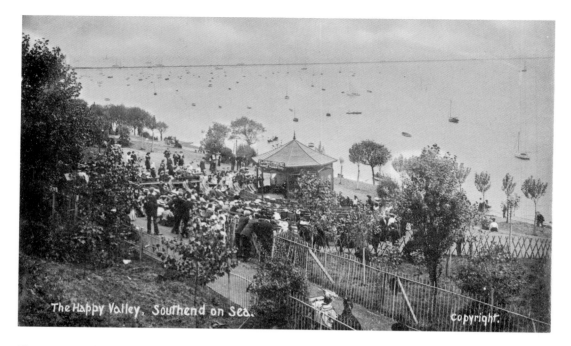

The Happy Valley, Southend on Sea. Copyright.

The Happy Valley, *c.* 1904

Entertainers at the seaside were almost there from the start: from the traditional beach performers with their Pierrot or naval costumes to those who performed in nearby gardens or along the seafront. With space on the sand at a premium in Southend and the effects of the tide, Westcliff and Southend developed some popular concert party sites. There was one in Shorefield's gardens, but probably the best known was Happy Valley. Will Newman's troupe is drawing a good audience here in 1904.

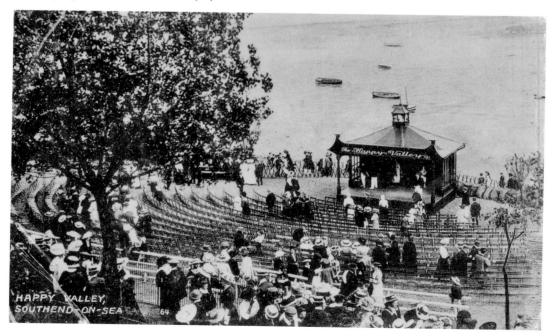

HAPPY VALLEY,
SOUTHEND-ON-SEA 64

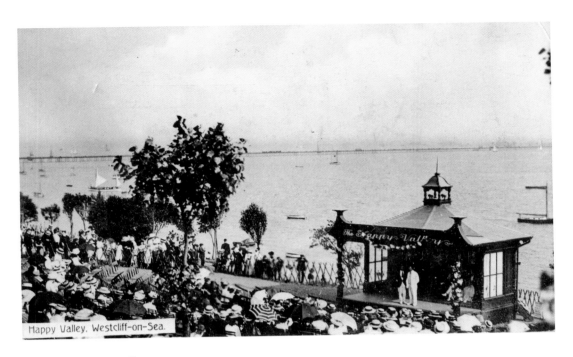

Happy Valley. Westcliff-on-Sea.

The Happy Valley, *c.* **1920**
The old bandstand was replaced by what was the original Cliff's bandstand in 1909. When Harry Rose's concert party was playing there before the outbreak of war in 1914, 3,000 or more would sometimes watch his shows. 'Everybody's saying it! I'll meet you at the Valley!' was his slogan and the crowds poured there to see them. After the war, the Floral Hall was built on the site and the concert parties continued until it was destroyed by fire in 1937. The Cliffs Pavilion carries on the tradition for entertainment today.

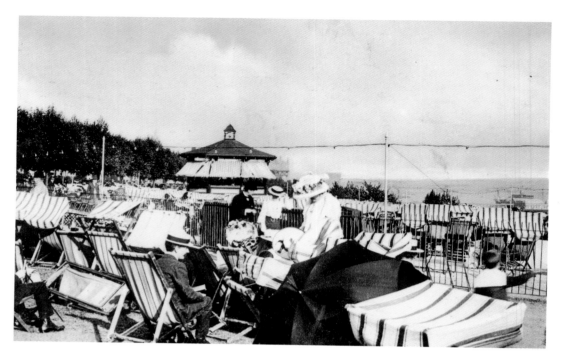

The Bandstand, c. 1909

Th image above shows the first bandstand on the Cliffs, erected in 1902. In 1909, this was replaced by the handsome structure quickly dubbed the 'wedding cake'. It was built by Walter McFarland & Co. of Glasgow at a cost of £750. With this bandstand, the one in the Happy Valley, two on the pier, and one opposite the Kursaal, there were plenty of opportunities to meet and listen to the band or see a concert party.

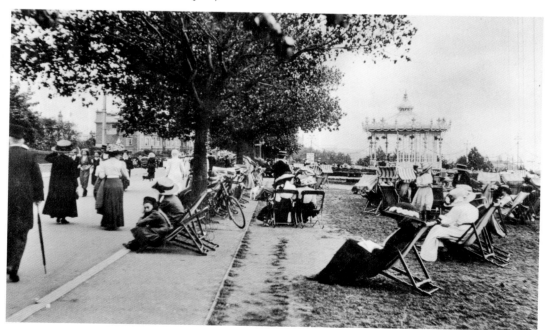

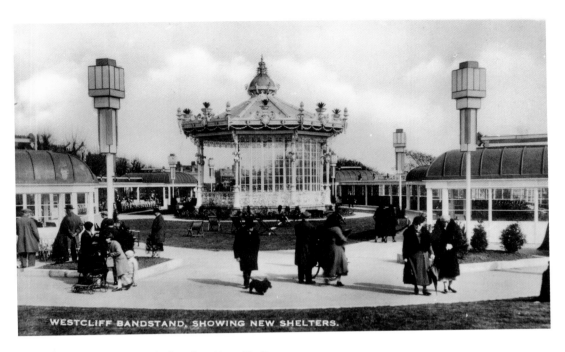

WESTCLIFF BANDSTAND, SHOWING NEW SHELTERS.

Westcliff Bandstand Showing New Shelters, *c. 1930*

With the new shelters audiences did not have to worry about the weather too much. Sadly, the Westcliff bandstand was demolished in 1956. In 1990 a simpler new bandstand was erected on the site. When there was a serious cliff fall in 2008 the bandstand was moved to Priory Park where it has proved very popular. Now the shelters have gone and the site with the cliff fall repaired awaits the building of what promises to be a magnificent £35 million development, including a museum, a planetarium, a restaurant-café and a shop built into the hillside with underground parking.

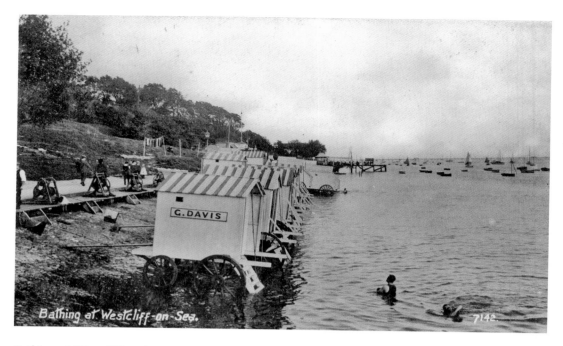

Bathing at Westcliff-on-Sea, *c.* 1910

In 1801, five-year-old princess Charlotte of Wales was send to Southend on medical advice for sea bathing. She stayed at The Lawn, Southchurch, and Mrs Glasscock, a well-known Southend 'dipper', soon published a business card claiming the honour of attending her. Dippers worked from these splendid machines, which could be pulled by horse in and out of the water or hauled by winches, which can be seen. Before around 1900 mixed bathing was not allowed on beaches. By the time of this photograph the machines are being used as changing huts for bathers.

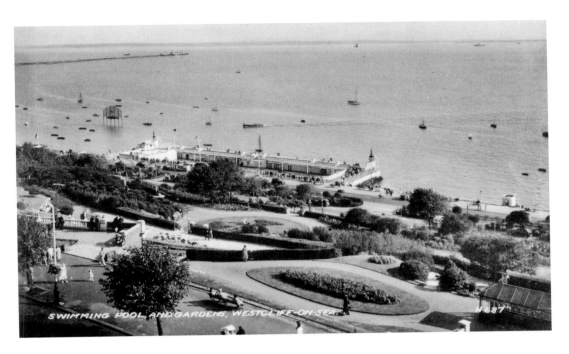

Swimming Pool and Gardens, *c.* 1935

Bathers had to use and pay for a bathing machine to change, so when a new public swimming bath was opened using the incoming tide to fill it with seawater, it made life much simpler. Between the wars, with the splendid new pool described as the largest in England, and then the magnificent public gardens, Southend and Westcliff prospered. The pool was built with enormously strong foundations to withstand the power of the sea, and although the foundations still survive, the pool was closed in 1969. After a short period as a Dolphinarium it was completely transformed into Maxim's Casino.

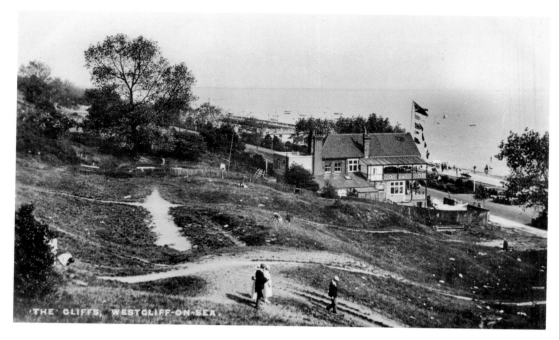

The Cliffs, *c.* 1925

The Nore Yacht Club and the Cliffs before the formal gardens were created in the late 1920s. The Nore Yacht Club was destroyed in May 1940 by German bombs. Southend found itself the target of bombing in both World Wars, possibly with enemy planes unloading bombs when the main targets could not be reached. In 1947, the Nore Yacht Club, which had been formed in 1902, joined with the Westcliff Yacht Club to form the Thames Estuary Yacht Club.

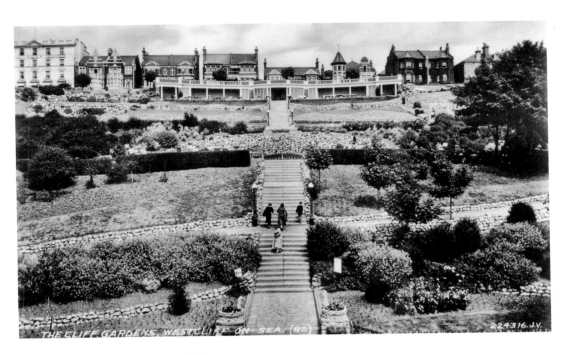

The Cliff Gardens, Westcliff-on-Sea, _c._ 1935

One of the features of the developing Southend-on-Sea were the cliffs where the first real resort began and gave the opportunity to develop the area down to the sea for informal and formal walks and entertainment. The Happy Valley was part of this and between the wars these impressive formal gardens, with wide steps, fountains and rose gardens, were developed. After some years of neglect following the loss of much of the holiday business, the gardens were restored in 2006 thanks to a large grant from the Heritage Lottery Fund.

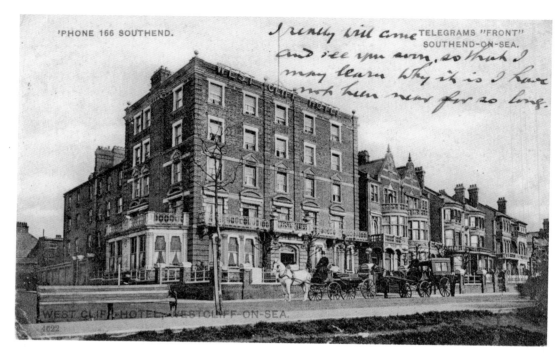

Westcliff Hotel, Westcliff-on-Sea, *c.* 1909

The Westcliff Hotel was built in 1891 as a temperance hotel. It occupies a splendid position on top of the cliffs and can claim to be the oldest surviving hotel in Westcliff. Today's hotel offers 'classic boutique-style rooms', private bathrooms and toileteries. Satellite television, a brasserie and all the comforts of a top-class modern hotel.

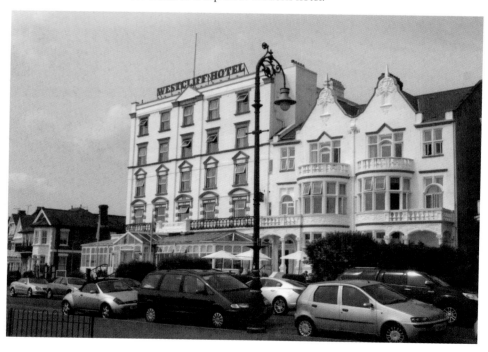

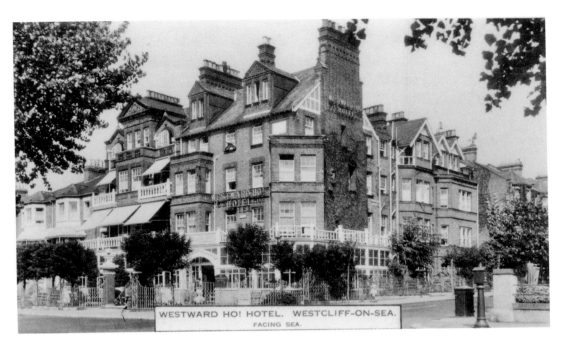

WESTWARD HO! HOTEL. WESTCLIFF-ON-SEA.
FACING SEA.

Westward Ho! Hotel, *c.* 1936

'The very best Position on Cliffs. Overlooking Sea. Near Bandstand. Spacious Dining Room capable of seating 200. Large Lounge, Drawing Room. Games Room and Billiard Room (full sized table). Excellent Cuisine. Lift to all Floors. Electric Light throughout. Amusements organised to suit all tastes. Terms from £4 guineas a week. Special Arrangements for City Gentlemen,' according to the 1925 *Southend-on-Sea Official Guide*. In the mid-1960s, with the hotel business struggling, the building was up for auction, but a disastrous fire led to its demolition.

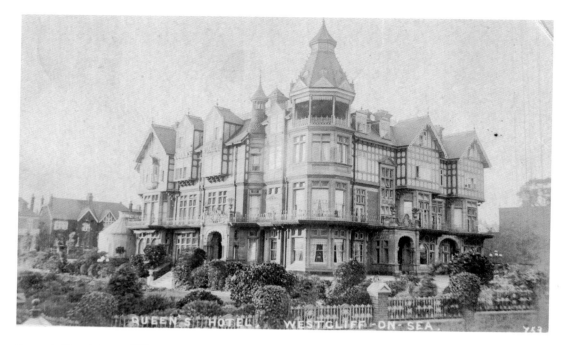

Queen's Hotel, Westcliff-on-Sea, 1907

'Luxuriously furnished throughout, standing in its own extensive grounds, is one of the most comfortable in the South of England and bears a high character for the excellence of its cuisine. Tastefully decorated ... the Hotel is lighted throughout with electricity. The corridors are all heated by steam. The Bed Rooms are large and bright and command an excellent view of the sea.' No wonder the writer of the postcard sent home to Paris describes it as '*trés chic ici*'. Built in 1898, the Queen's at the bottom of Hamlet Court Road sadly, after a fire, was demolished in 1989.

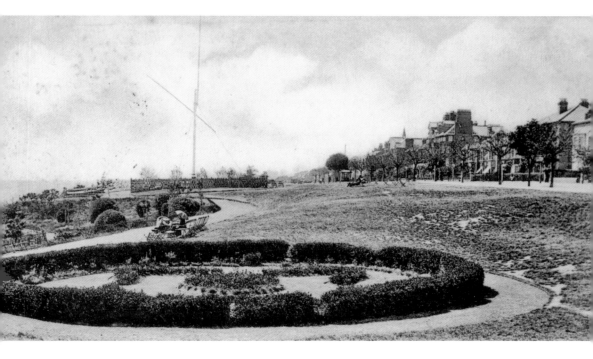

Westcliff, 1903

The above image shows the flagpole, which was later removed when the site was chosen for the war memorial. This area still maintains some of the Victorian shelters and provides peaceful walks with stunning sea views.

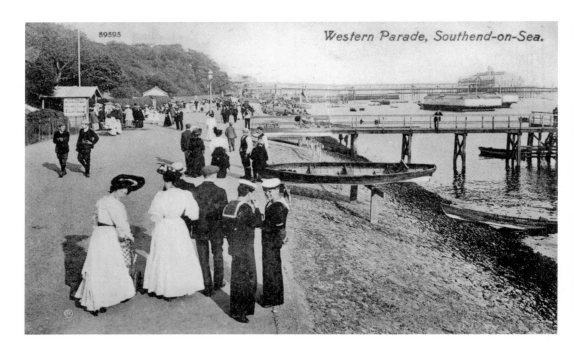

59595

Western Parade, Southend-on-Sea.

Western Parade, Southend-on-Sea, c. 1910

Two fascinating innovations to ponder. To the right of the photograph in the distance can be seen floating baths owned and operated by the Absalom family. The Absaloms were local entrepreneurs but the floating baths, one for women and children and one for gentlemen, moored near the pier, were laid up for the First World War and put out of business by the council, who built and opened the new open-air swimming pool in 1915 and refused to allow the floating baths to be moored again. To the left the sign on the hut reads: 'Why Walk? Quickest Way to the Railway Station and Cliff Band.'

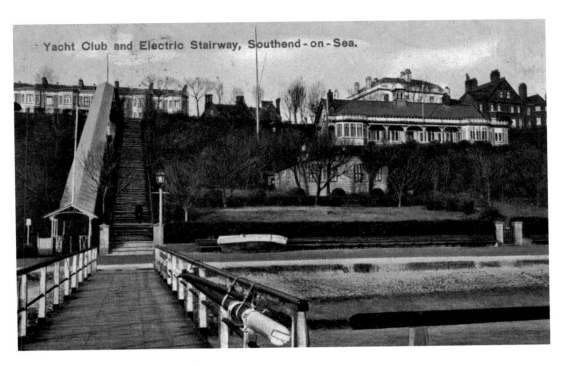

Yacht Club and Electric Stairway, Southend-on-Sea.

Yacht Club and Electric Stairway, *c.* **1910**
The answer to that question: 'Why Walk?' A new Reno Electric Stairway would carry you effortlessly up the cliff and for only one penny. The American Jesse Reno's invention came to Southend in 1901 and was built close by the impressive Alexandra Yacht Club clubhouse, opened in 1884. The Reno stairway only lasted for ten years.

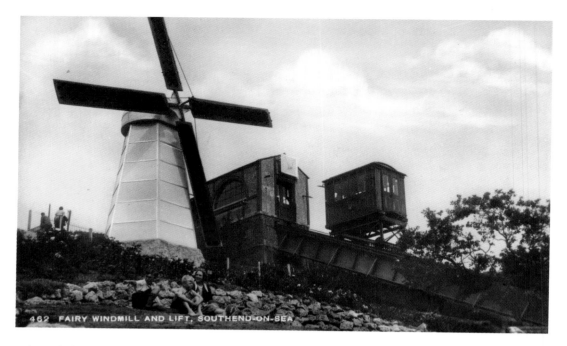

462 FAIRY WINDMILL AND LIFT, SOUTHEND-ON-SEA

Fairy Windmill and Lift, *c.* 1930
The electric stairway was replaced by the funicular Cliff Railway. By this time the Corporation owned all the Cliff area. Built by Waygood & Company, it opened in 1912, and over the years it has had many refurbishments with the last one completed in 2010 costing £3 million. It is operated by the Southend Museum Service. The Fairy Windmill was part of Never Never Land when, from 1935–72, this part of the Shrubbery was transformed into a world of magical castles and characters, including a model railway and all lit up from dusk. A grander scheme reopened in 1987 but only lasted four years.

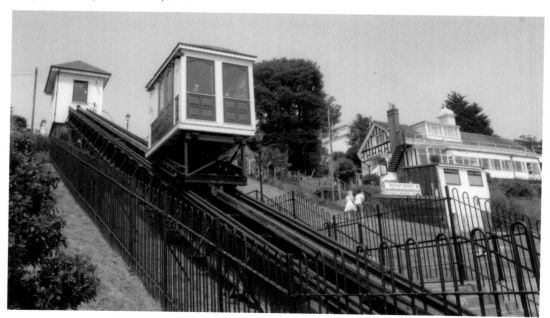

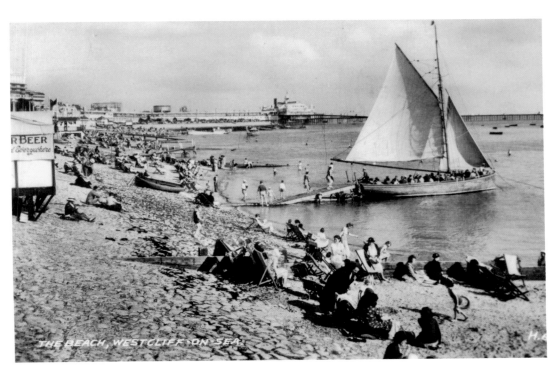

The Beach, Westcliff-on-Sea, *c.* 1939
Another lively photograph from the late 1930s, with boat trips proving particularly popular.

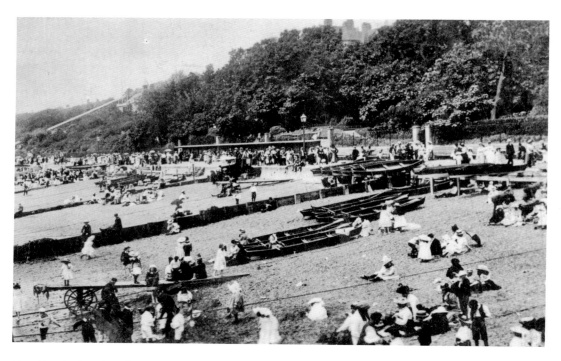

East Beach, Southend-on-Sea, c. 1906
The line of the Reno stairway can be seen in the distance. This was a popular part of the beach below the Shrubbery and still is today, where the new award-winning Three Shells Beach next to the Three Shells Beach Café has been created. This is an ideal spot for families with younger children.

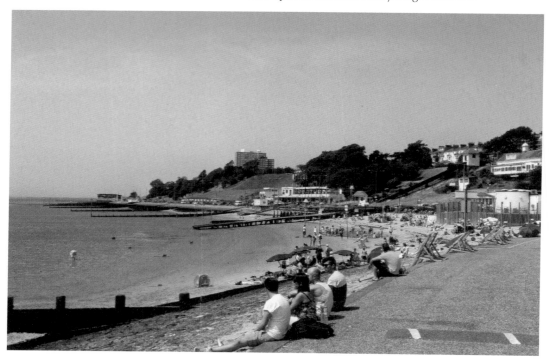

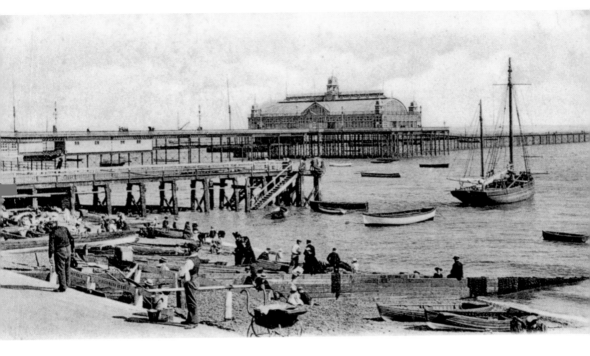

Beach and Pier, *c.* 1904
Today's photograph from the top of the Cliff railway gives a better view of the popularity of the Three Shells Beach on a sunny day.

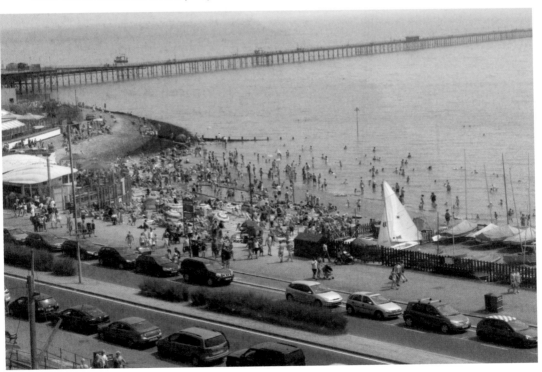

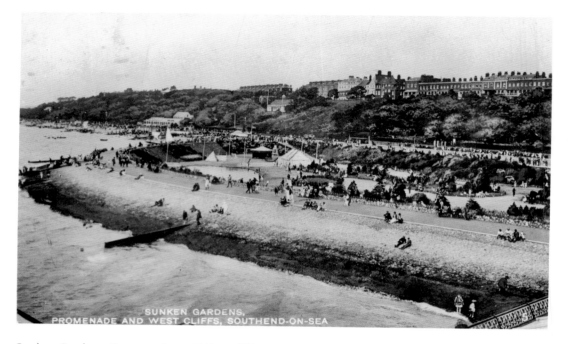

SUNKEN GARDENS,
PROMENADE AND WEST CLIFFS, SOUTHEND-ON-SEA

Sunken Gardens, Promenade and West Cliffs, *c.* 1929

The Sunken Gardens on reclaimed land were formed after the iron pier replaced the earlier wooden structure. In Edwardian times, the Royal Pavilion stood in the Sunken Playground and concert parties performed there throughout the summer. The Sunken Gardens developed after the First World War as a simple children's playground in 1924. In the bottom photograph (posted in 1930) the marquee carries the lettering 'Daily Express children's playground. Free'. It was eventually renamed Peter Pan's Playground with a very popular speedway track for small cars and a growing number of attractions.

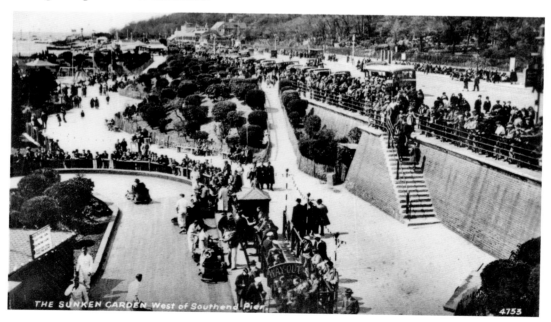

THE SUNKEN GARDEN West of Southend Pier 4753

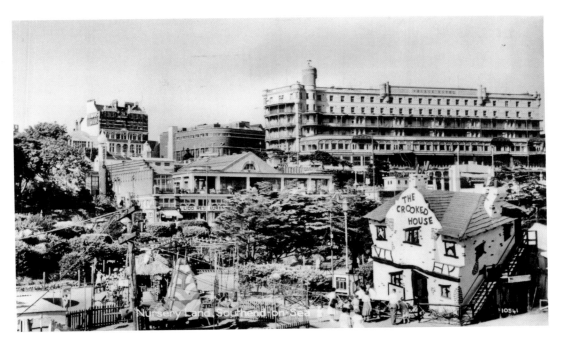

Nursery Land, Southend-on-Sea, *c.* 1960
The much loved Crooked House, still there today, and other attractions. In 1976, the amusement park was purchased by Philip Miller and family and further developed with more up-to-date rides. In 1995, this site to the west of the pier was linked to the amusement park to the east of the pier and it all became known as Adventure Island. In the left distance can be seen the Grand Pier Hotel, opened in 1909 and demolished in the 1980s to make way for the Royals Shopping Centre.

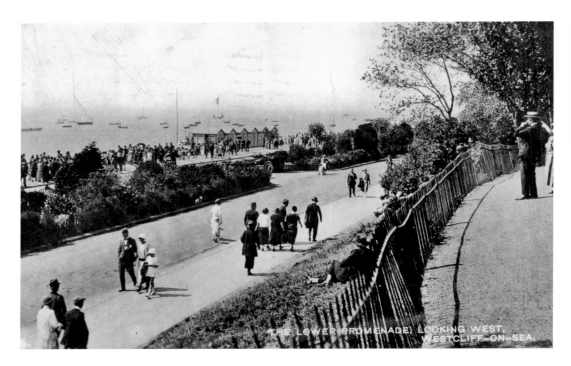

Lower Promenade, Looking West, Westcliff-on-Sea, *c.* 1927
'It's jolly fine down here. The weather is quite decent but blowy. Went pillion riding yesterday at 9 o'clock in the evening. Very nice. Love Vera.' A message that suggests Vera would have enjoyed today's attractions in Adventure Island.

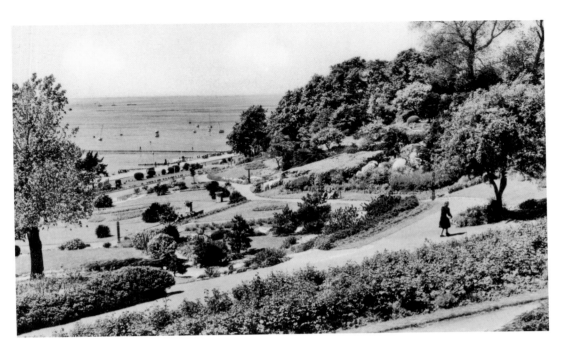

View from the Flower Gardens

A view of the Shrubbery with the new steps to the Royal Terrace in the foreground. Southend has managed to combine many of the old features of the gardens and quiet walks with modern attractions. If the English seaside is to compete with foreign holidays then combining heritage features with up-to-date attractions seems to be working for Southend.

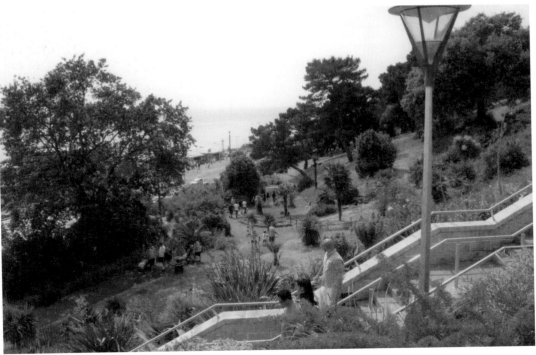

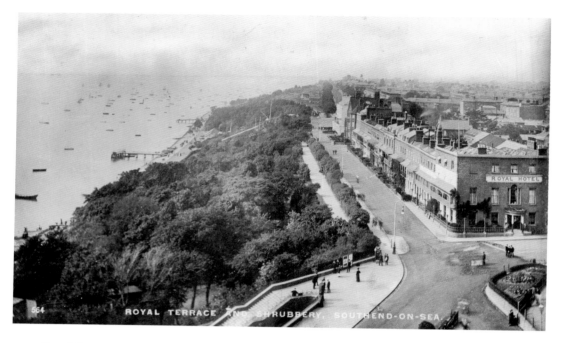

Royal Terrace, c. 1920

In 1791, a syndicate was formed to develop a seaside resort at New Southend on the western edge of the higher land above the wooded cliffs. Thomas Holland began developing the Grand Hotel and the terrace. The Grand Hotel opened in 1793 with a ball for 170 guests. Now the emerging resort had a centre for social life where the people of fashion and money could stay. Sadly, there was an economic slowdown, partly because of the war with France and partly because of the competition around the coast.

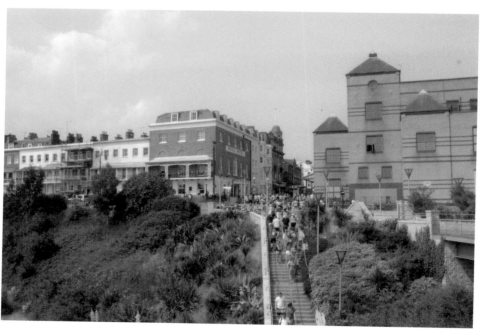

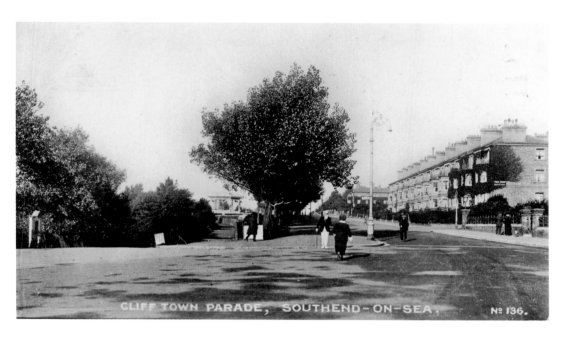

Cliff Town Parade, c. 1920

Thomas Holland was bankrupted and James Heygate purchased 'A leasehold Estate ... Capital Hotel and Assembly Room ... and fifteen substantial well-built convenient houses ... delightfully situated on a noble Promenade.' In 1803 Princess Caroline stayed at numbers 7, 8 and 9 the terrace for six weeks. Following this visit by the Princess of Wales the terrace was renamed Royal Terrace and the hotel became the Royal Hotel. In 1803 or 1804 the Royal Warm Water Baths were built by the Ingram family in the south-east corner of the Shrubbery. A pony provided the horse power to pump water from an artesian well. In 1879 the baths were demolished.

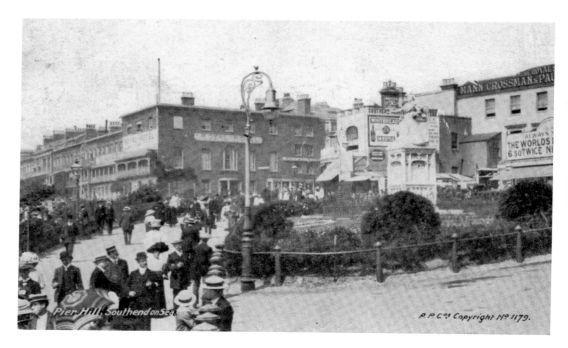

Pier Hill, Southend-on-Sea, c. 1910

Before the Royals development, the Grove Picture Palace had a short existence on Pier Hill, from 1909 to 1920. The massive investment in the Royals Shopping Centre on Pier Hill, which opened in 1988 and now houses some thirty major shops, is undoubtedly a huge attraction for locals and visitors who enjoy shopping as a leisure pursuit. The vertical cliff lift opened in 2004 links the seafront with the upper level and provides stunning views of the pier and the seafront.

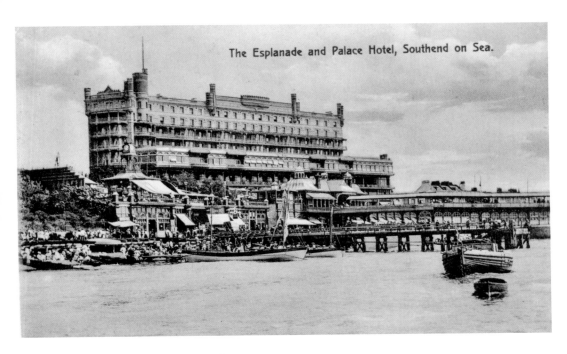

The Esplanade and Palace Hotel, Southend on Sea.

The Esplanade and Palace Hotel, *c.* 1911

A photograph showing some of the Pier Hill buildings, which included a bandstand, seawater baths and restaurants. Most of these went in the 1970s. As road traffic increased in the twentieth century the road was cut through in front of the pier. The magnificent Palace Hotel was designed by James Thornton for Mr Chancellor. Dated 1901 and intended to be known as the Metropole, the expense was too much for Mr Chancellor and the building was purchased by Alfred Tolhurst and renamed The Palace.

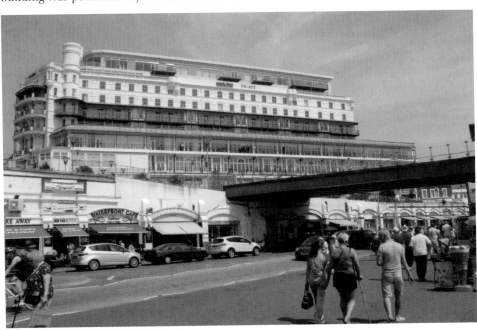

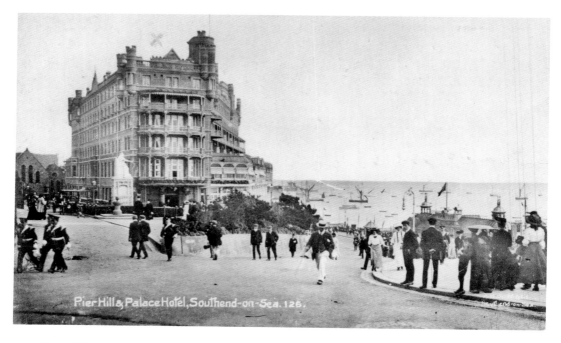

Pier Hill & Palace Hotel, Southend-on-Sea. 126.

Pier Hill and Palace Hotel, *c.* 1915

From its elevated position on Pier Hill the Palace Hotel looks out over the pier and the sea. Pier Hill was for a while a fairground, a feature of which was a switchback railway. The hotel has suffered changing fortunes over the years, including use as a retirement home and apartments sold privately. However, in 2010 it has been splendidly refurbished and opened as the Park Inn by Radisson Palace, offering 137 rooms, many of them with magnificent views over the Thames Estuary. Today's view shows the Royals Shopping Centre in the foreground.

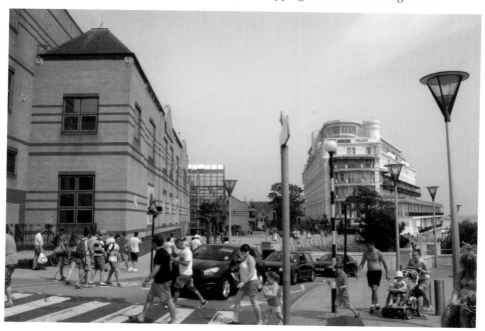

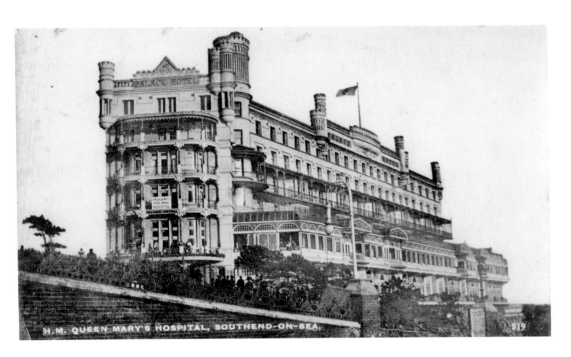

HM Queen Mary's Hospital, *c.* 1916

During the First World War the hotel was offered to the military as a hospital and became the Queen Mary Royal Naval Hospital. The message is from a convalescing service man: 'My own Darling Wife ... the big building is the hospital, so you will know it when you come ... I am putting in for the railway pass for you in the morning ... in your letter you said you wished it was nearer so you could slip down for a few hours. So now you have a fine chance and I should like you to have a change again Darling for a week or two, it would do you good.'

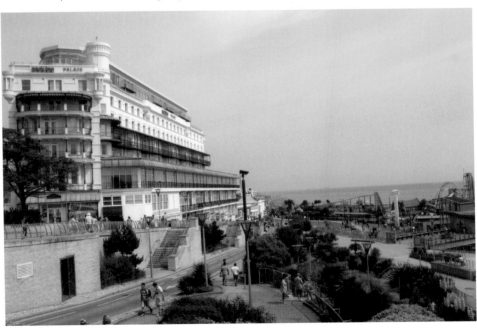

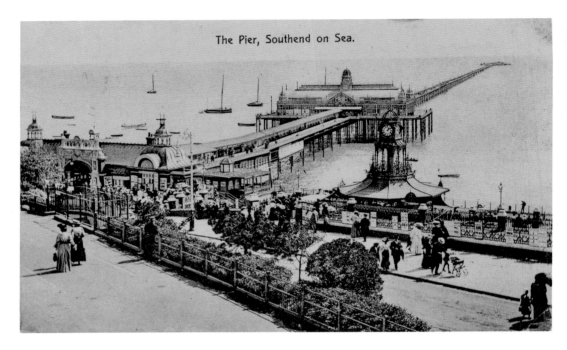

The Pier, Southend on Sea.

Queen's Statue and View of Pier, *c.* 1910
Queen Victoria sits splendidly on Pier Hill pointing out the gentlemen's toilets to the trippers. The local joke cannot now be used as in 1962 it was moved to Cliff Town Parade to look out over the sea there. The statue was presented to the town in 1897 by the Mayor Alderman Bernard Wiltshire Tolhurst to mark the Queen's Diamond Jubilee. The elegant structure with the clock above it was the Pier Hill bandstand and a concert party stage.

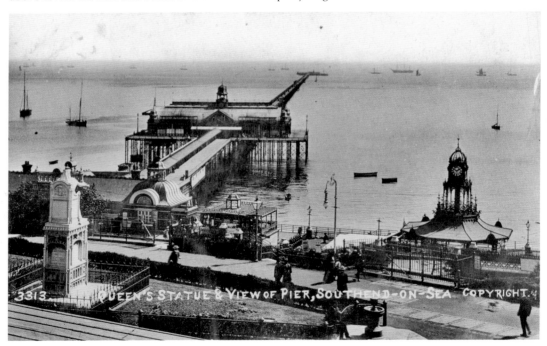

3313 QUEEN'S STATUE & VIEW OF PIER, SOUTHEND-ON-SEA COPYRIGHT.

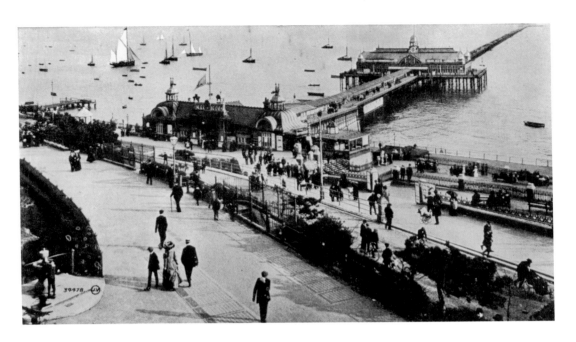

The Pier, c. 1915

Sir John Betjeman remarked: 'The pier is Southend and Southend is the Pier.' It must be the most famous pier in the world. In 1820, Southend was described as 'a quiet place for quiet people'. For the place to really grow as a resort it would be essential to enable boats to bring trippers and holidaymakers and a pier was needed. In 1829 the first pier bill was passed. By 1833 there was 1,500 feet of pier and then a causeway to a mount with a lighthouse, locally called 'Mount Misery' by the Leigh fishermen, as they considered it a hazard.

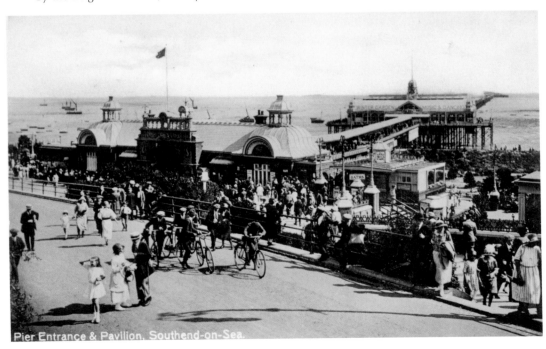

Pier Entrance & Pavilion, Southend-on-Sea.

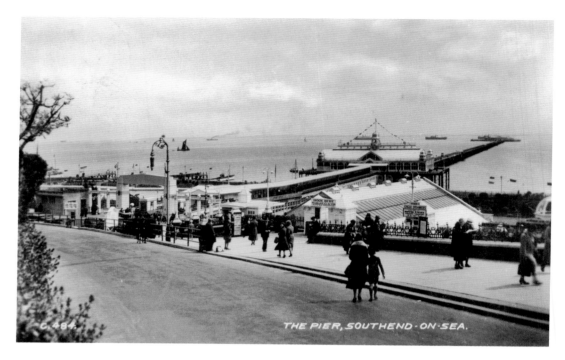

The Pier, c. 1939

By 1846 the pier was 1¼ miles in length. In 1887, as more and more trippers were coming to Southend, a new iron pier was built alongside the wooden one and opened in 1889 with the added attraction of a single track electric railway built by Cromptons of Chelmsford. In 1989 a new pier head was opened. Between 1939 and 1945 the pier saw war service as HMS *Leigh*.

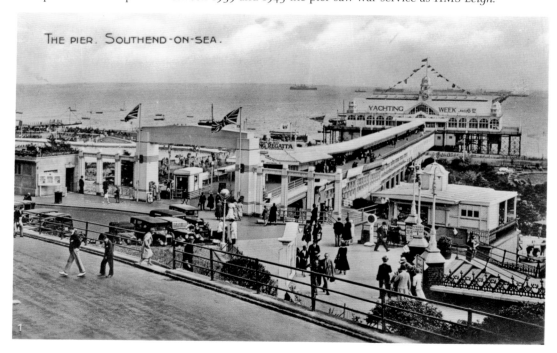

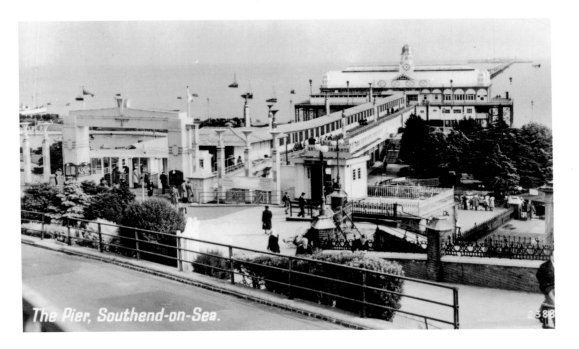

The Pier, c. 1965
In 1959 the pier pavilion was destroyed by a fire and replaced by a Ten Pin Bowling Alley. In 1995 the Bowling Alley was also destroyed by a fire. In 1980 the pier faced the biggest challenge of all when it was proposed to close it. A grant from the Historic Buildings Committee in 1983 led to a £1.3 million renovation of the pier that was completed in 1986. Later that same year the MV *Kingsabbey* smashed into the pier, damaging the lifeboat house, which took three years to repair.

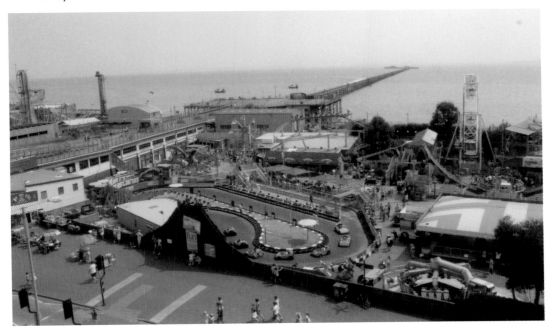

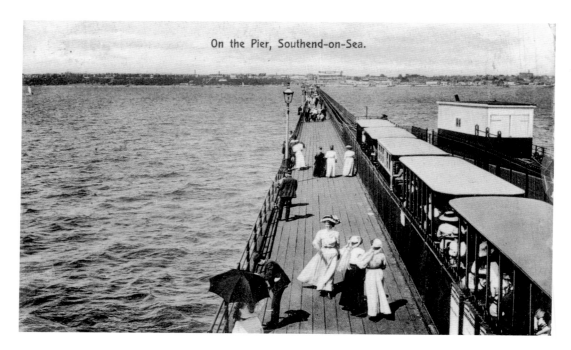

On the Pier, Southend-on-Sea.

On the Pier, *c.* 1912

Paddle steamers could call and depart from the cliff head. In 1898 a new pier head was formally opened to cater for the number of passengers arriving and departing. One of the early toast rack carriages can be seen today in the Pier Museum and other exhibits from the railway saved over the years. The renovation in the 1980s included a new railway and rolling stock, with the new railway opening in May 1986.

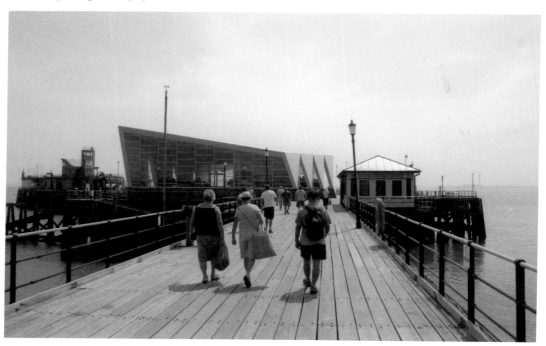

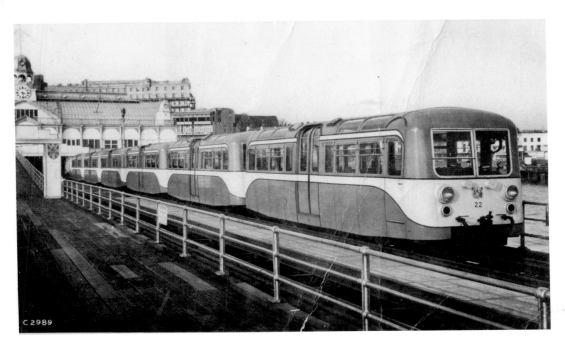

One of the Four New Electric Trains, c. 1951

This rolling stock was replaced in the 1986 renovation and today the *Sir William Heygate* and the *Sir John Betjeman* take holidaymakers up and down the pier for the sheer pleasure of it or the relief of not having to walk the mile or more to the attractions at the end of the pier. A trip on the train to the end of the longest pier in the world is a must for any visitor to Southend and I defy anyone not to be excited by the experience.

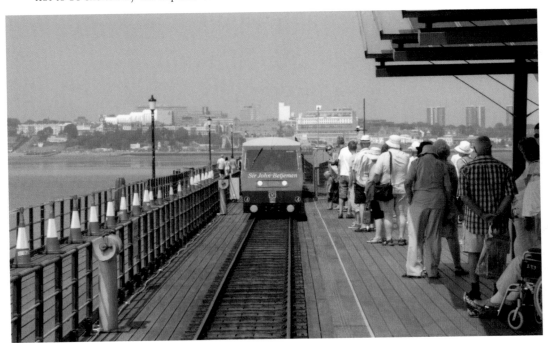

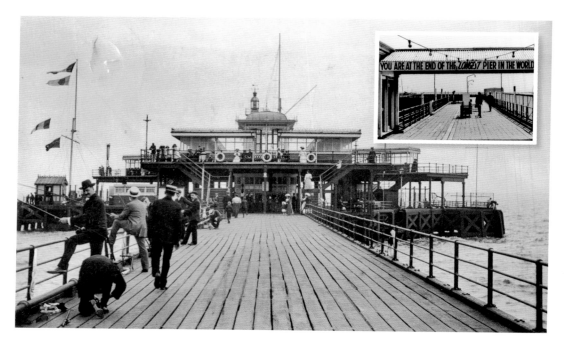

The Pier Head, *c.* 1911
What was left of this charming pier head building was lost in a terrible fire of 1976. Cafés, the Sun Deck Theatre, amusements arcades and the coastguard station were lost. In 2012 an elegant new wooden pavilion with a café was opened. Renamed the Royal Pavilion this year, it is hoped the main hall, which can seat 185 people, will stage exhibitions, theatrical events and concerts.

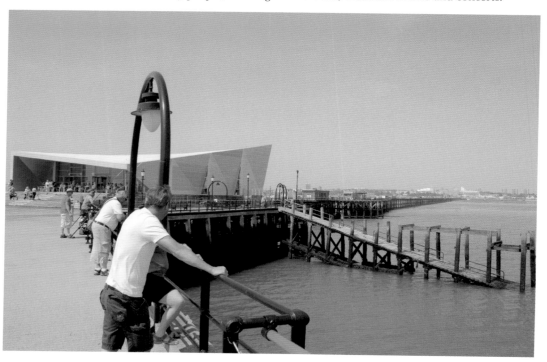

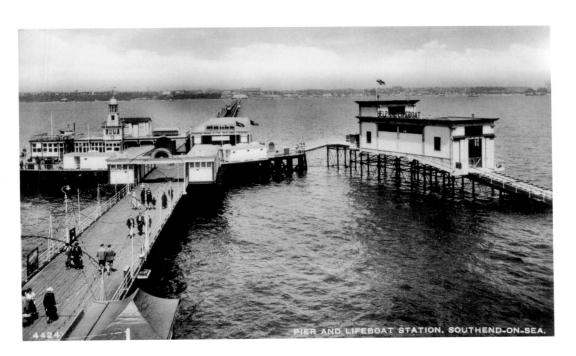

Pier and Lifeboat Station, *c.* 1935
After the disasters in 1986, which destroyed the lifeboat station, a new RNLI lifeboat station with gift shop and sun deck were constructed at the end of the pier and officially opened in June 2002. Southend Pier is one of the great survivors. She has survived two wars, collisions, fires, the ravages of time, competition from cheap overseas holidays, the whims of local councillors and still she is renewed and reborn by an admirably forward-looking borough council as one of the great symbols of the English seaside.

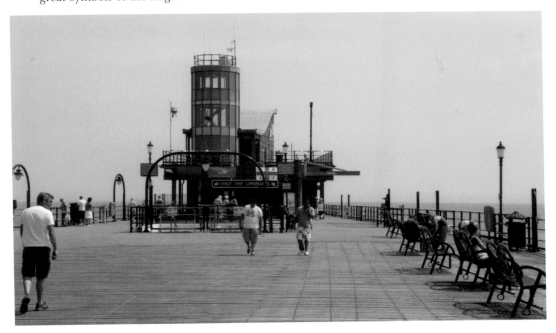

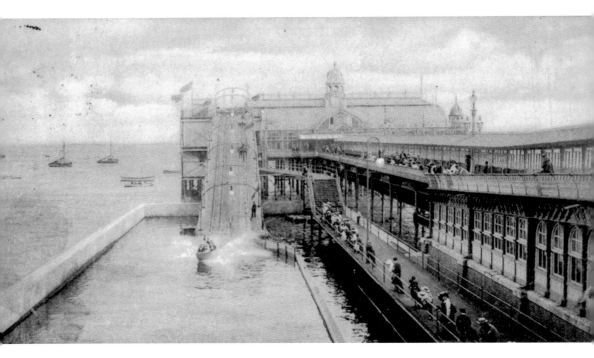

The Water Chute, *c.* **1904**
In 1902 Mr Munn built a splendid water chute on the eastern side of the pier. It wasn't successful and by 1905 it had been dismantled. The basin was used as a boating lake between the wars and quite a congested one too judging from the photograph below.

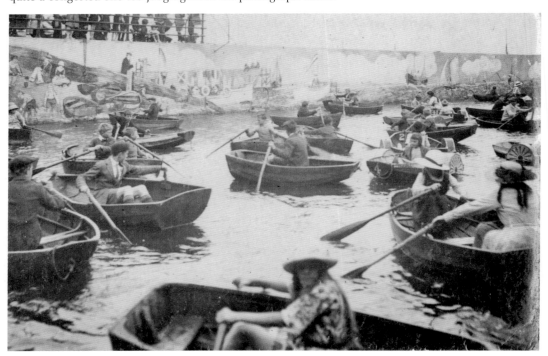

The *Golden Hind*, c. 1960

After the Second World War a new attraction was ordered for the empty basin. Whatever it was it had to give work to unemployed Southend seamen. The result was a replica of Sir Francis Drake's *Golden Hind*, the ship in which he circumnavigated the world. The ship was also used to house a waxworks collection. The new attraction opened in 1949 and proved popular. In 1997, however, it closed and the site was acquired by the Adventure Island operators, who replaced the ancient ship with the *Queen Anne's Revenge*, Blackbeard's pirate ship. In January 2013 that attraction was demolished.

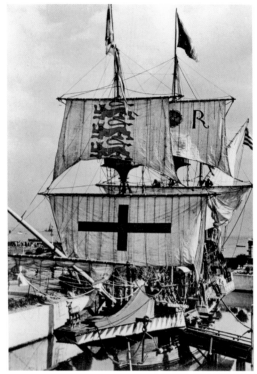

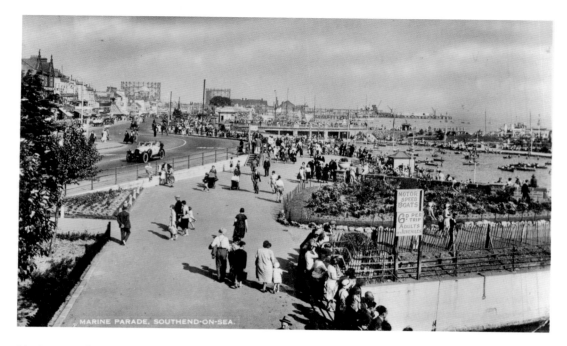

Marine Parade, *c.* 1933

The basin advertises 'Motor Speed Boats, Adults and Juveniles *6d* per trip'. This section of the seafront along with the pier is the essence of Southend. Here were most of the attractions and the cafés, while Westcliff was more select. The message on this card, sent on 22 August 1933, reads, 'Managed to scrape a fortnight at Westcliff and a fine place it is too. The pc gives a view which you would not like but within three minutes the view is altered and you have the Westcliff cliffs and this is far removed ... Having good weather and a quiet holiday.'

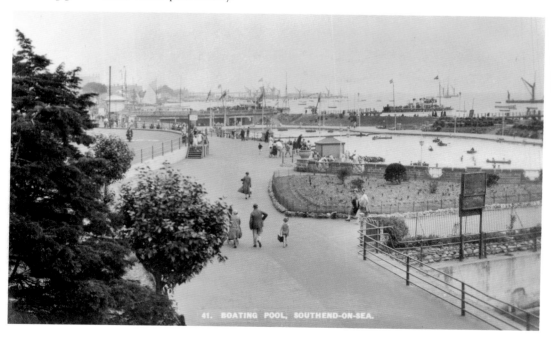

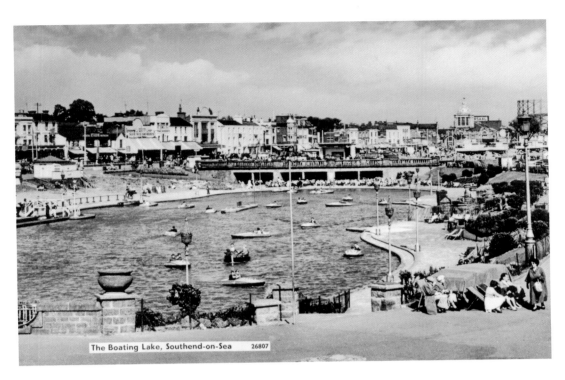

The Boating Lake, Southend-on-Sea 26807

The Boating Lake, *c. 1960*
The Boating Lake, which opened in 1930, continued as a large feature of the seafront for nearly fifty years before losing its appeal. It is very calm and sedate compared with the thrills of today's Adventure Island.

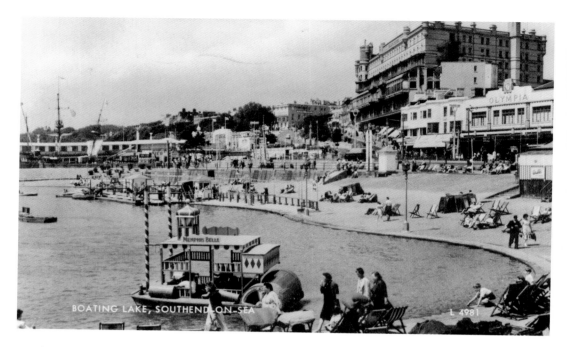

Boating Lake, *c.* 1960

Today's young people are thrill seekers and the free admission fun park has something for all ages from Rage, for 'superheroes only' to massive water chutes, roller coasters and adventure golf for those who want something less stomach churning. For those that all this dropping, spinning and looping the loop builds an appetite, there are numerous fast-food outlets.

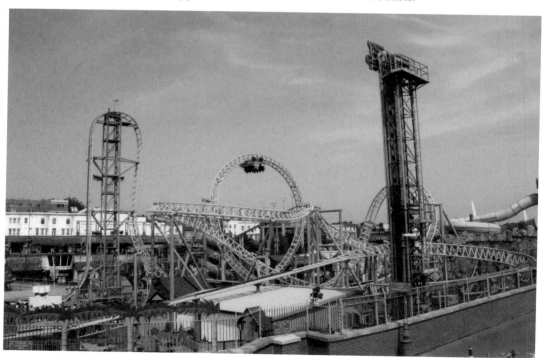

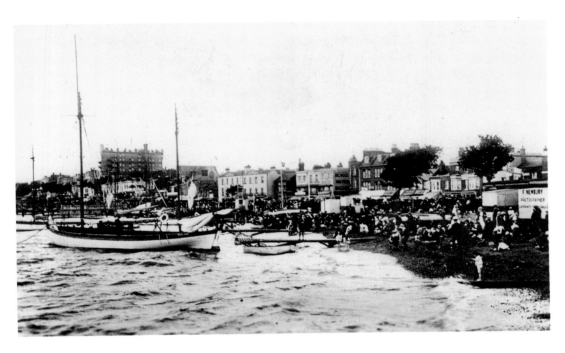

East Beach, Southend-on-Sea, c. 1912

By 1911 the population of Southend had risen to 62,723, so in around a hundred years the town had grown from a small watering place to a bustling and prosperous holiday resort and home for London commuters. This whole section of the beach from the pier to Thorpe Bay was extensively improved as a result of work on the sea defences and reopened in July 2003 as the Jubilee Beach. The section close to the Kursaal is now known as the City Beach and the promenade boasts the strange digital lighting columns that lean rather dramatically in today's photograph.

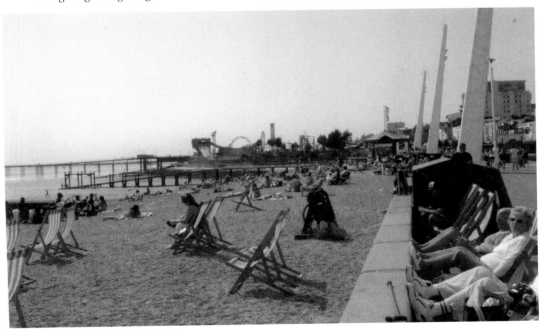

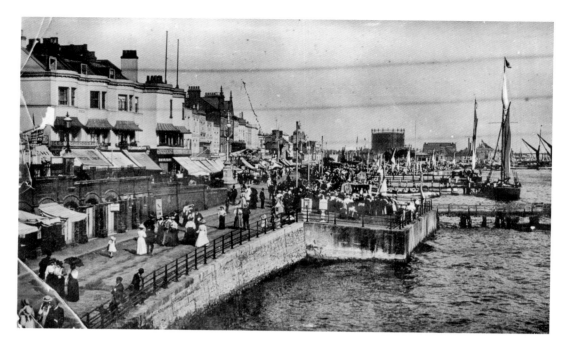

Marine Parade, Southend-on-Sea, c. 1906
The Boating Lake became possible when there were extensive works on Marine Parade in the early years of the twentieth century. The new Marine Drive was laid out and areas reclaimed from the sea. It has continued to change over the years. This is Southend's 'Golden Mile' and was full of the 'trippers', despised by some for their vulgar ways but welcomed by restaurants, public houses and those providing amusements and entertainment.

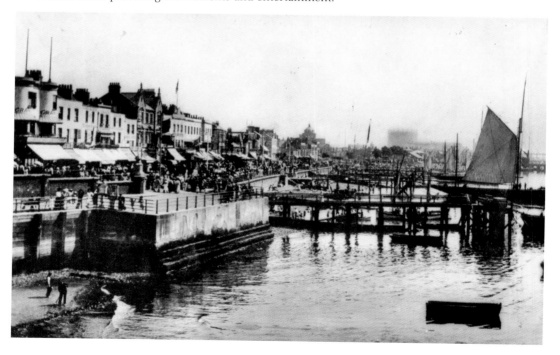

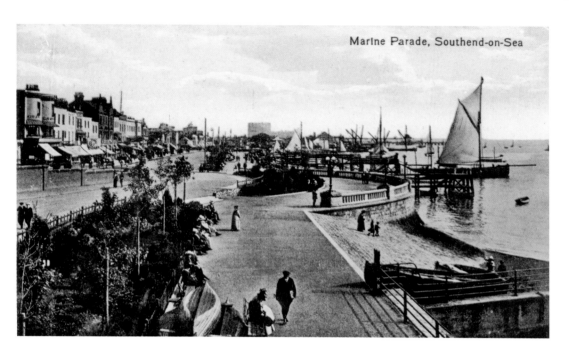

Marine Parade, Southend-on-Sea, *c.* 1914

The new Marine Parade is taking shape and the considerable widening of the promenade can be seen. 'London on the Mud' was one description of Southend. The key to its development was its accessibility, especially after the railway came from the populous crowded streets of the East End of London. It was the day trippers who made Southend. Perhaps a paddle, a walk, just a sit in the sun, as long as you kept the head covered, this was living. A fish supper, an ice cream and then all too soon back to the daily grind.

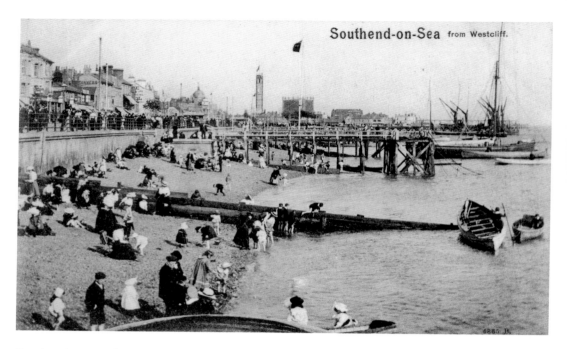

Southend-on-Sea from Westcliff.

Southend-on-Sea from Westcliff, *c.* 1902

Two features of the seafront in the distance centre, one short lived and one much longer. The revolving tower was erected in 1898 and removed in 1905. The first Warwick Revolving Tower was in America and they quickly came over here to Scarborough, Morecambe, Great Yarmouth and Southend. The tower could lift 150 people to a height of 126 feet. Landmarks such as the gasometers are now no longer there.

The Beach, Southend-on-Sea

The Beach, Southend-on-Sea, *c.* 1928

'The sand was there to sit on ... there were cockles and winkles and whelks. There was beer and tea and ice-cream cornets and wafers. There was sunshine and burnt arms and noses. Bathing huts for those who wished to immerse themselves in the sea although more paddling was done than complete immersion. On a Bank Holiday many who were hardy enough slept under the pier, the structure from the upper part of the slope to the level of the entrance forming a good shelter from the night weather and untouched by the tide in its ebbing and flowing.' (Cyril Braysher Pearse)

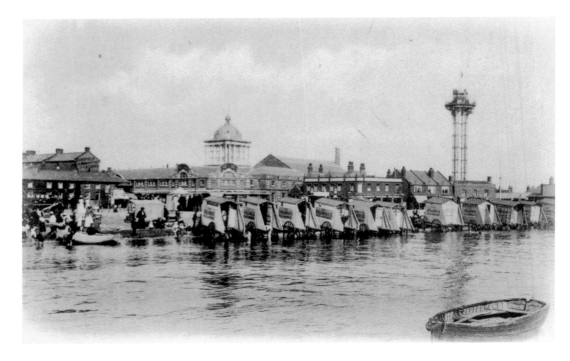

Bathing Beach, Kursaal and Tower, c. 1902
The Kursaal (meaning 'cure hall') has just opened in this image. Darbyshire's Guide for 1904 says, 'the Kursaal Company provided an attraction in their palatial suite of buildings which will meet the requirements of Southend-on-Sea for many years to come...' The ballroom could accommodate 2,000 dancers and there was a stage at one end. The dining hall was said to be the finest in the country and could seat 1,000 diners. Adjoining were some 26 acres of park with cricket, a cycling track, an open-air café, roundabouts, swings and a switchback.

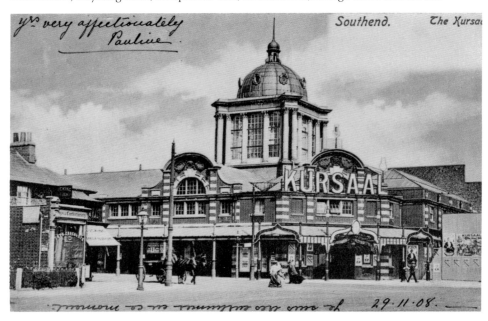

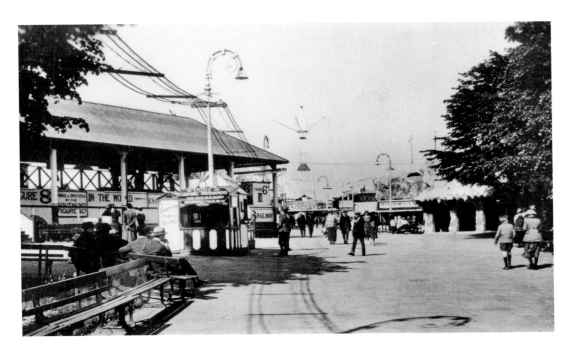

General View, Kursaal, c. 1928

The park closed in 1973 and was developed for housing. The main building closed in 1986, and was eventually purchased by the Southend Council. The main building, designed by Campbell Sherrin, with its landmark dome was protected by being given Grade II listing and the Kursaal reopened in 1998. 'The Magic Returns', the sign says, and one of the modern attractions is ten pin bowling and pool tables, a function suite for weddings and corporate events.

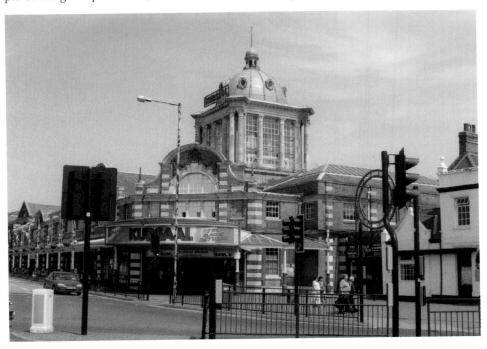

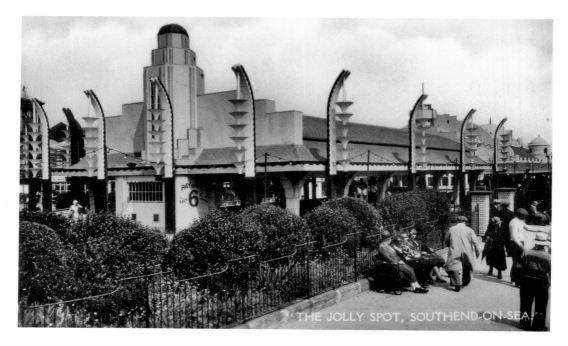

The Jolly Spot, Southend-on-Sea, *c.* 1930

'We are the Jolly Boys, we're here to make you laugh...' and three times a day from Whitsun through to mid-September they did so. The Jolly Boys were a Southend institution. They began on the beach as five men with a harmonium then, in 1904, they took over a regular pitch at the bandstand opposite the Kursaal. Four hundred and fifty could be seated and they would stage extra shows when it was wet. The Jolly Spot was built by them to replace the bandstand. This closed in 1953 and the site is now a car park. The nearby Sea Life Centre is a modern attraction.

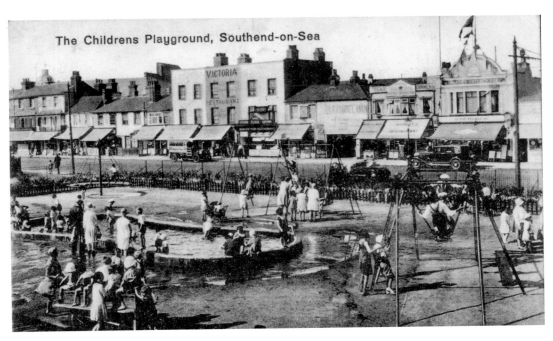

The Children's Playground, Southend-on-Sea

The Children's Playground, Southend-on-Sea, *c. 1932*
Inexpensive fun for the children, compared with the attractions of today. The street scene is full of restaurants to cater for the holidaymakers: Jaquests, the Beehive, the Victoria Restaurant and a fish and chip shop. While the old playground is now mostly car parking and the Sea Life Centre, just along the Marine Parade is a very popular replacement for children to enjoy by getting soaked with fountains that shoot up from the paving.

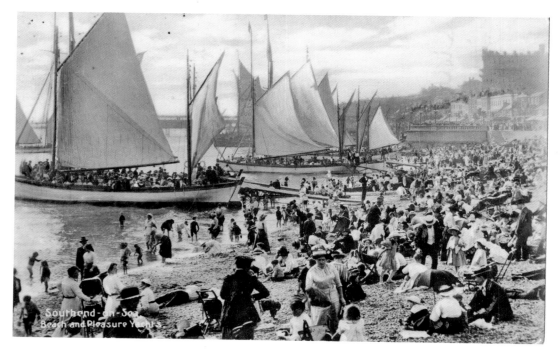

Beach and Pleasure Yachts, *c.* 1924

Thousands poured in to find a small space on the narrow beach and enjoy the pleasure yachts. These sailing yawls had earlier worked as salvage vessels or giving assistance to sailing vessels. The arrival of the steamships and steam tugs left them looking for other work which they found at resorts like Southend. 'Cycled to Southend 23 July 50. What weather poured part of the time, but still had a wonderful time. Remember the Ghost Train and laughing ... shall never forget.'

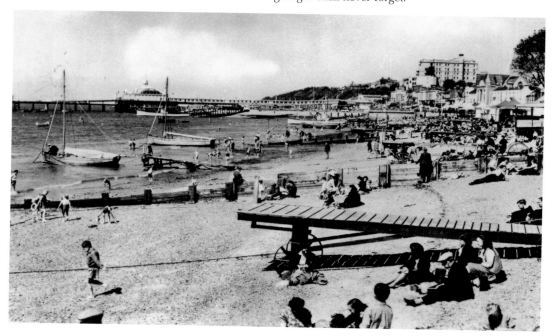

The Beach and Pier, Southend-on-Sea, *c.* 1960
The motor launch *Dreadnought* has replaced the yachts. The *Dreadnought* was built in the 1930s and was in operation until the mid-1980s. Speedboat rides are still offered from the beach when the tide is in. One of the features of Southend, of course, is that the tide does go out a very long way, revealing miles of mud.

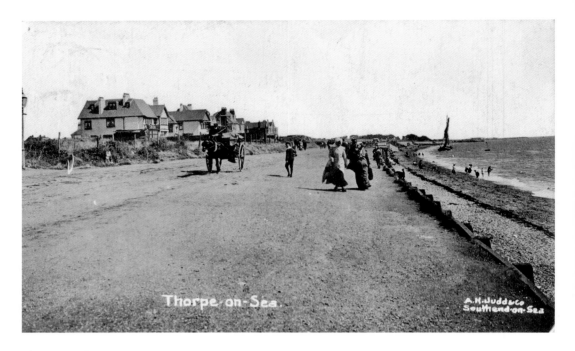

Thorpe-on-Sea, *c.* 1911

Thorpe Hall had been bought by Colonel Ynyr Henry Burges. In 1907 Thorpe Hall had been converted into a golf club and new estate streets were laid out. In July 1910 the railway station opened called Southchurch-on-Sea at first, but the name was almost immediately changed to Thorpe Bay. Thorpe Bay was going to become a fine new resort, but the First World War delayed plans. Seen below around 1914 with the bathing machines, it appears very quiet.

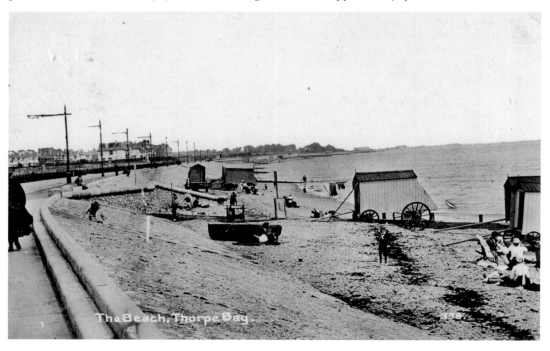

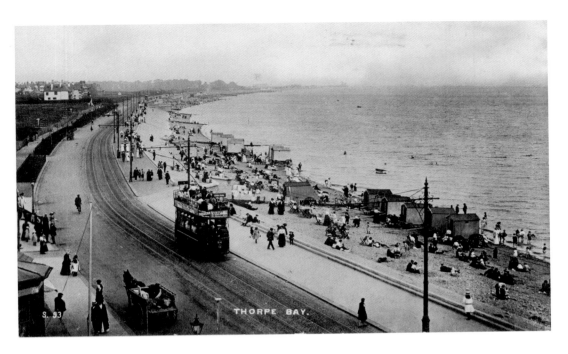

Thorpe Bay, c. 1919
Southend's tram system opened in 1901 and was steadily expanded. In February 1912 the track reached Thorpe Bay. What a boon it must have been to the holidaymakers as it is about 4 miles from Thorpe Bay to the pier. Trolley buses were brought to the streets of Southend in 1928 and ten years later motor buses really announced the end of the trams. The tramway system finally closed in 1942.

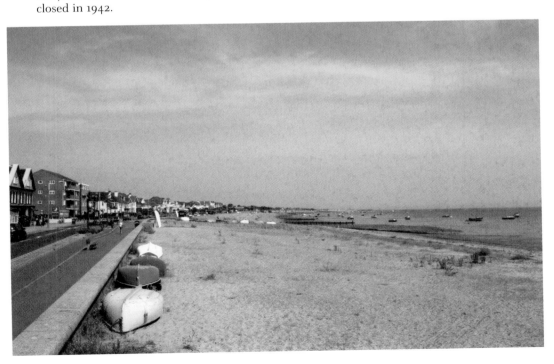

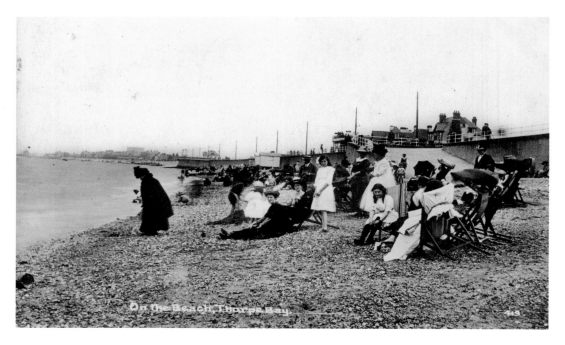

On the Beach, Thorpe Bay, *c.* 1912

'Very pleased to tell you that Mamma is feeling very much better for the second week. We have had glorious weather, so if we have a little rain we cannot grumble. What do you think of this place? We have been to nearly every place but we like this the best.' The photograph below is from around the same time and sent by Muriel to her friend Win in London: 'I should like to have a week end here with you, jolly fine place where I am staying.'

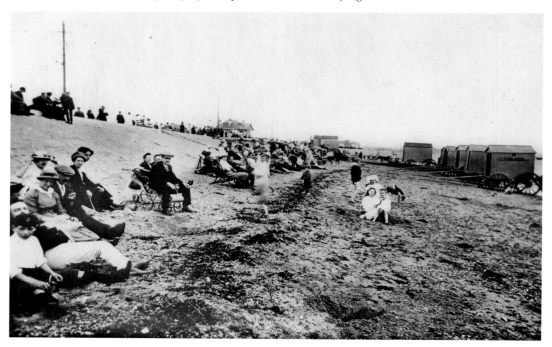

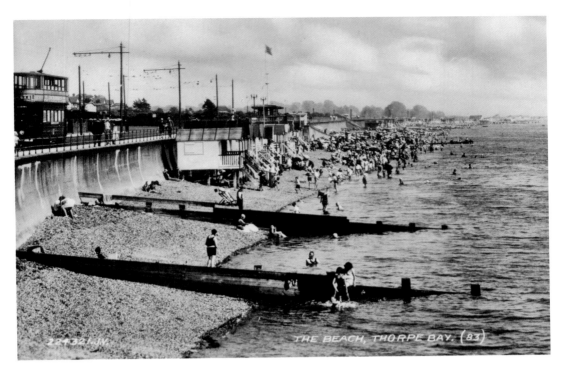

The Beach, Thorpe Bay, *c.* 1938
Trams are still running along the esplanade and a wonderful row of beach huts on stilts has developed along the edge of the sand. Thorpe Bay has obviously developed between the wars and now the beach is almost as crowded as at Southend.

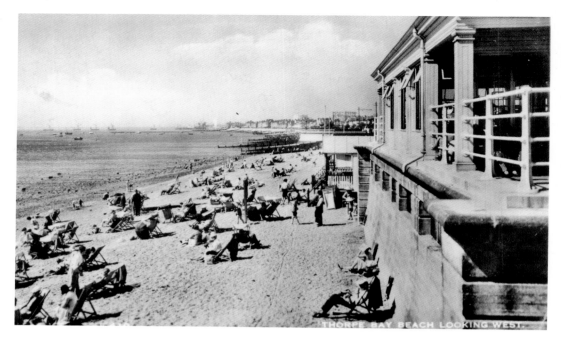

Thorpe Bay Looking West, *c.* 1959

The 'Tram Stop', a feature on the Thorpe Bay seafront, which at the time of the photograph after the trams had stopped running was being used as a shelter and changing rooms for bathers, has been derelict for many years. The Burges Estate Residents Association had high hopes of restoring it for community use, but structural damage means that demolition and a total rebuild, if the funds can be raised, is the only realistic option.

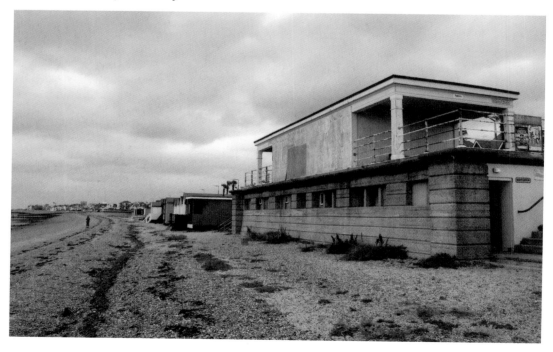

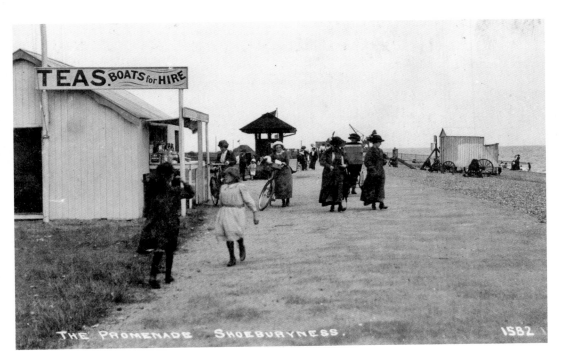

The Promenade, Shoeburyness, *c.* 1912
Shoeburyness is associated with the artillery barracks, but this is the part of the beach at the end of the Thames Estuary. There is a café and other facilities creating a busy and popular spot particularly for water sports. In one direction is the excitement of Southend and in the other the call of the open sea and the huge vessels passing by.

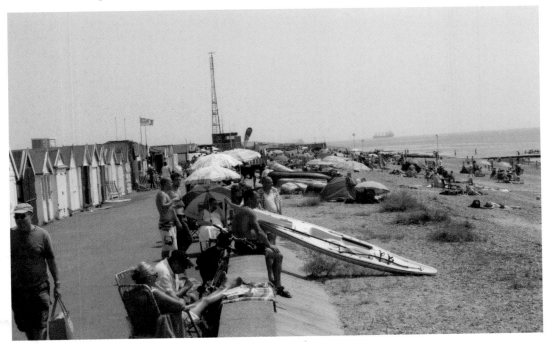

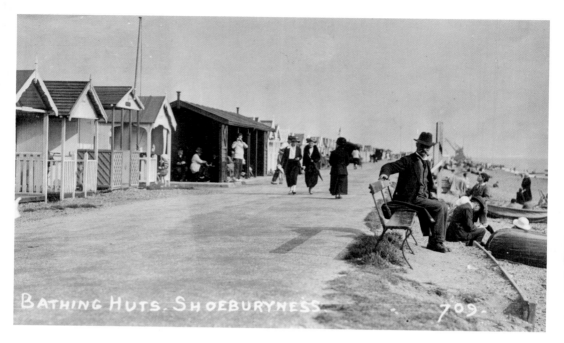

Bathing Huts, Shoeburyness, c. 1912
Our love of the seaside reaches perhaps its peak in the ownership of a beach hut. That cherished property with sea views and easy access to the beach is a haven for escape, more expensive per square foot sometimes than our permanent residence. It is an Englishman's small castle by the sea and long may it be so.

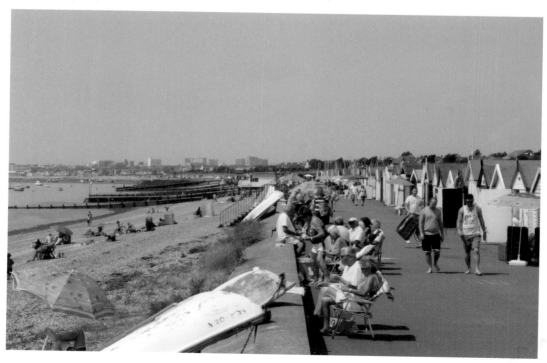

STEP INTO NATURE

By Ponds and Streams

Written by Michael Chinery
Illustrated by John Gosler

GRANADA

Published by Granada Publishing 1984
Granada Publishing Limited
8 Grafton Street, London W1X 3LA

Copyright © Templar Publishing Ltd 1984
Illustrations copyright © Templar Publishing Ltd 1984

British Library Cataloguing in Publication Data
Chinery, Michael
 By ponds & streams.– (Step into nature; 5)
 1. Freshwater ecology – Great Britain –
 Pictorial works – Juvenile literature
 I. Title II. Series
 574.5'2632'0941 QH137

 ISBN 0-246-12176-9

Series devised by Richard Carlisle
Edited by Mandy Wood
Designed by Mick McCarthy
Printed in Italy

Contents

This is a river! 4
At the water's edge 6
The noble swan 8
A fishy feast 10
An aquarium at home 12
The patient fisherman 14
Prickly sticklebacks 16
The playful otter 18
Come dance with me! 20
Diving for dinner 22
Croaking in chorus 24
Hiding in the reeds 26
Slow-moving snails 28
Wriggly newts 30
A pond in your garden 32
Dazzling dragonflies 34
A toothy torpedo 36
Dabbling and diving ducks .. 38
Walking on water 40
Picture index 42

No matter where you live, you are surrounded by nature. In the towns, even in the cities, you will find birds and animals, flowers and trees, bugs and grubs to watch and wonder about. STEP INTO NATURE is about all these things – the everyday creatures as well as the elusive. It's packed with nature projects to do, nature diaries to keep and clues and signs for the nature detective to read. It will teach you how to look at the world of nature around you, how to understand its working and how to conserve it for others.

This is a river!

This picture shows a typical lowland river. The water in it flows along quite slowly so lots of bulrushes and other plants can grow in the shallows near the bank. In fact, the water is almost still at the edge of the river and water lily leaves can float quite peacefully there.

A great deal of animal life can also be seen in and around the water. Frogs leap after insects on the lily leaves and mayflies flit about overhead. The yellow wagtail on the left of the picture darts after flies, while the brightly coloured kingfisher dives for fish. All are watched by the patient heron, whose long beak will snap up any fish that comes within reach. You can see from this that rivers are wonderful places in which to explore nature, but always be careful: river banks are often soft and slippery and can easily give way and send you into the water!

If you know a stretch of river nearby, look at a local map and see if you can find out where it starts and finishes. Try to visit the different parts of your river. You will find it doesn't look the same all the way along. At the beginning, known as the *source*, it is a mere trickle, but a little lower down it gets wider and faster as other small streams join in with it. Its bottom or bed is made of rock or large boulders because the fast current carries the soil and smaller stones away. Lower still the river widens further and its current slows down a little so plants can grow at the edges and on its gravelly bed. Then comes the lowland stretch, like that in the picture, where the bottom turns to mud, enabling even more plants to grow. Finally, the river becomes a broad estuary and enters the sea. Use your *Nature Diary* to record what you see in different parts of the river.

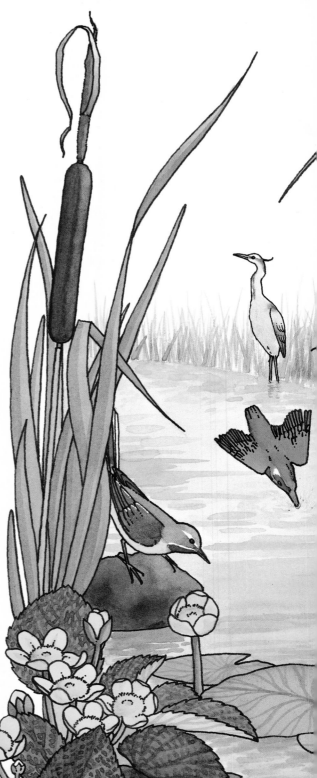

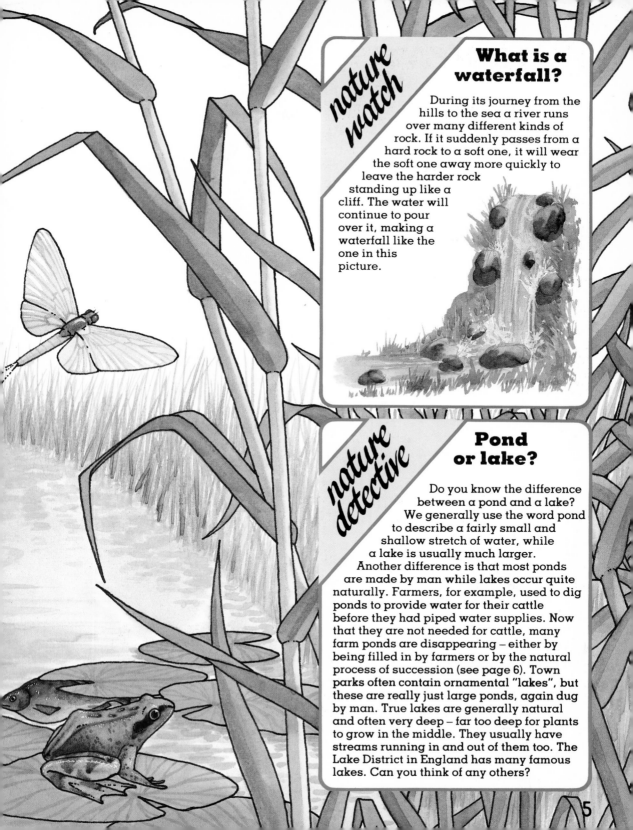

What is a waterfall?

During its journey from the hills to the sea a river runs over many different kinds of rock. If it suddenly passes from a hard rock to a soft one, it will wear the soft one away more quickly to leave the harder rock standing up like a cliff. The water will continue to pour over it, making a waterfall like the one in this picture.

Pond or lake?

Do you know the difference between a pond and a lake? We generally use the word pond to describe a fairly small and shallow stretch of water, while a lake is usually much larger.

Another difference is that most ponds are made by man while lakes occur quite naturally. Farmers, for example, used to dig ponds to provide water for their cattle before they had piped water supplies. Now that they are not needed for cattle, many farm ponds are disappearing – either by being filled in by farmers or by the natural process of succession (see page 6). Town parks often contain ornamental "lakes", but these are really just large ponds, again dug by man. True lakes are generally natural and often very deep – far too deep for plants to grow in the middle. They usually have streams running in and out of them too. The Lake District in England has many famous lakes. Can you think of any others?

5

At the water's edge

Have you ever visited your local pond? Unless it's in a park where it has been regularly cleaned, you'll probably have had to push your way through lots of plants to reach the open water. These waterside plants are special in many ways – their roots don't mind the water-logged soil and contain large, air-filled spaces to help the plants breathe. You can see some such plants on this page.

Next time you visit a pond, you might notice that the plants grow in definite zones. Furthest from the water's edge are the marsh plants, growing in damp soil. Next come the swamp plants, like rushes and bur-reed, which grow right by the water with their roots almost always in the shallows. Further out there are plants which are rooted in the mud on the bottom of the pond itself. Some, like the water lily, have their leaves floating on the surface, while others, like Canadian pondweed, are completely submerged. In most ponds you'll also find some plants that float freely in the water. These floating plants do have roots of a sort, but they are not anchored to the mud or soil like most other vegetation. One of the best known is duckweed, which forms green carpets over many ponds in the summer.

Many of these water plants can also be found along the edges of slow-moving rivers. They do not grow in faster streams, though, because the current would wash them away. In fact, because they can grow unhindered by currents, the swamp plants around a pond are actually slowly destroying it. Mud builds up around their roots and eventually rises above the water level. The plants gradually spread in towards the middle, and the whole pond eventually becomes a swamp and then dry land.

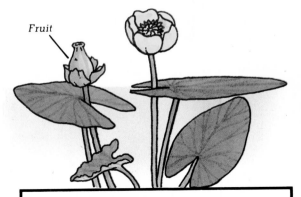

Fruit

The **yellow water lily** can grow in quite deep water. The plant is also known as the brandy bottle because of the shape of its fruit.

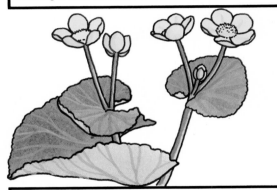

The **marsh marigold** or **kingcup** is a low-growing marsh plant. You'll find it in damp fields and on the banks of ponds and streams.

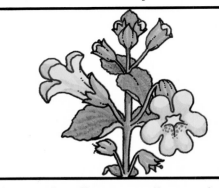

The **monkey flower** usually grows by rocky pools and streams – often by waterfalls where it gets plenty of spray.

Up to 250cms high

Up to 120cms high

Up to 200cms high

Reedmace or **bulrush** grows in the shallows. The brown club contains thousands of fluffy seeds.

Purple loosestrife is a marsh plant found growing on muddy banks around ponds and rivers.

Indian balsam is also known as policeman's helmet because of its flower shape. It grows on river banks.

Up to 90cms high

Up to 100cms high

Up to 150cms high

Male flower spike

Female flower spike

Arrowhead grows in the shallows. Some leaves stand upright to give it its name. Others are oval and floating.

Branched bur-reed is a swamp plant growing at the edges of ponds and slow-moving rivers.

Lesser pond sedge is another swamp plant. The male flowers, producing yellow pollen, are at the top.

The noble swan

The swan is one of the world's heaviest flying birds, weighing up to 20 kg which is as much as a small child. Try to watch one taking off: it has to run over the water for quite a long way before it gets airborne. But once in the air it flies rapidly, holding its long neck outstretched like those in the big picture on the right. Listen out for the throbbing beats of the swans' large wings when you see them flying overhead.

The swans in the big picture are mute swans. Look for them on lakes and slow-moving rivers and also on the lakes in town parks. They live in Britain all the year round, unlike the two in the panel below which visit us only for the winter. They get their name because mute means silent, and this swan rarely uses its voice. It will hiss loudly if alarmed, though, especially if it has youngsters. And the male, which you can see stretching his wings on the right of the picture will not hesitate to attack dogs and even people if he thinks they might harm his family. He will raise his wings and even bite if he gets the chance, so try not to disturb him. Notice that the black knob on his beak is bigger than that of the female.

Mute swans like water with plenty of vegetation. They feed mainly on water weeds, often plunging their graceful necks deep into the water to pull up leaves and even roots. Their nests are usually made from large heaps of plant material, sometimes put together on the bank and sometimes anchored to the reeds in shallow water. The female lays about six eggs, which hatch after about five weeks. The babies, called cygnets, can swim after a day or two, but cannot fly for several months. They stay with their parents for the summer and sometimes until the next spring. They do not lose their grey colour until then.

Winter swans

nature watch

Two other kinds of swan – the whooper and Bewick's – visit us for the winter. They fly down from their breeding grounds in the far north because at this time of year all the water there freezes and everything is covered with snow. The whooper swan is slightly larger than Bewick's swan and makes a lot more noise. It gives out a loud *hoop-hoop-hoop* call as it flies. Look at the different beak pattern of the swans. Even from a long distance you can tell that these are not mute swans – can you see the differences in their necks? As well as feeding on lakes and rivers, the winter swans roam through the fields, often in large flocks, looking for grain and tasty plants to nibble. You can also see them swimming in sheltered bays around the coast. Look for the prints of their large webbed feet in the mud.

Bewick's swan

Whooper swan

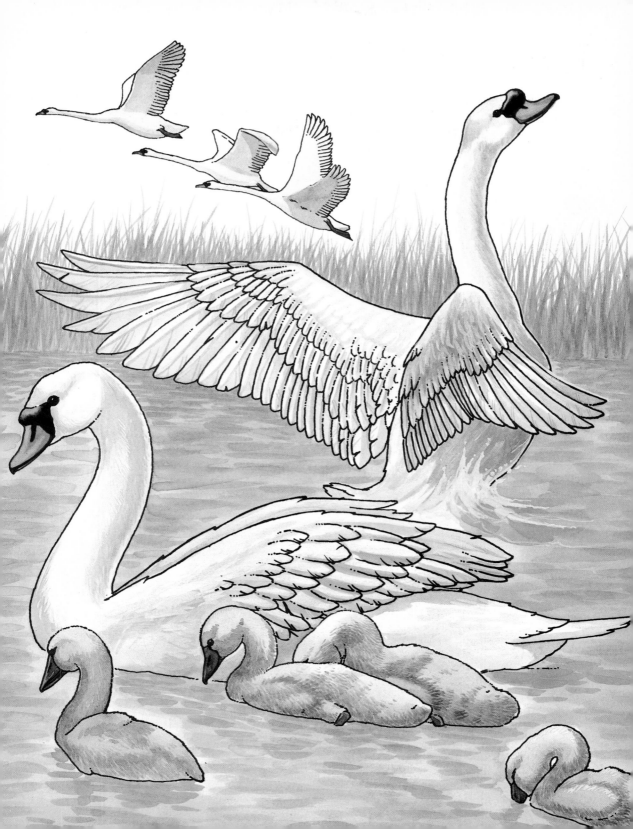

A fishy feast

Have you ever wondered what fish eat? In fact, most of our freshwater fish are omnivores, which means that they will eat almost anything that they can find. They nibble away at plants and are always nosing about at the bottom of the pond or stream, sucking in rubbish in the hope that some of it will be edible. In fact, most of the debris is spat out again, but sometimes they find tasty tit-bits to eat. If you make an aquarium like the one on page 12, you can watch your own fish doing this.

The fishes' most important foods, however, are provided by the hordes of tiny animals that swim or drift through the water or lie buried in the mud. Some of these mini-beasts are shown on the opposite page. They themselves feed on even smaller creatures or on microscopic plants and debris that are also floating about in the water. Young mosquitoes are a favourite food for many kinds of fish. In some places fish have even been added to ponds to control the mosquito population.

Dipping into a pond

nature project

You can see some of the pond's mini-beasts if you lie down on the bank and gaze into the water. But this is not always possible, and it certainly isn't always comfortable! A much better way of looking at these interesting creatures is to use a small net to capture them and then to examine them in a small container.

1 You can buy a small aquarium net from a pet shop and use this for pond-dipping, but it is quite easy to make one for yourself – perhaps with a bit of help from a grown-up with the sewing. All you need is a ring of stout wire attached to a short stick, and a piece of muslin or the foot of an old stocking for the bag. Loop this over the wire and sew it together like the one in the picture below. You can then sweep it through the water weeds and shallow water to catch the animals.

2 Empty your net frequently into a soup plate or similar white dish full of pond water. You will be able to see the animals quite easily then. Remember to put them back when you have finished.

3 You can examine small animals even more easily in a simple trough like the one below. Make it with two pieces of glass and some modelling wax. Add the water and animals with an eye-dropper.

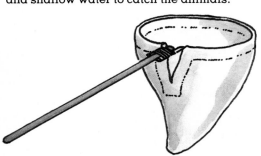

Modelling wax

Clips to hold the trough together

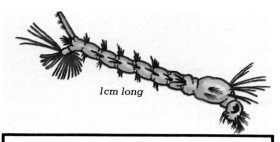

1cm long

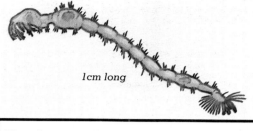

1cm long

The **young mosquito** lives in still water, wafting minute food particles into its mouth with the help of the bristles on its head.

The **phantom larva** is almost invisible in the water. It grows up into a mosquito-like midge, although it does not suck blood.

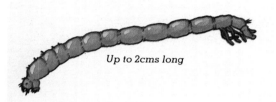

Up to 2cms long

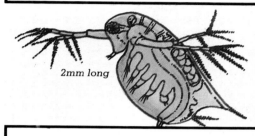

2mm long

The **blood-worm** lives in the mud, usually in a slender tube-like home. It grows up into a mosquito-like fly which does not bite.

The **water flea** jerks its way through the water by beating its large, branched antennae. Also called daphnia, it is a popular fish food.

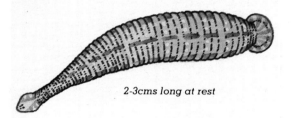

2-3cms long at rest

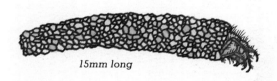

15mm long

Leeches are flesh-eating or blood-sucking worms. Short and fat at rest, they become long and ribbon-like when they swim.

Caddis fly larvae often build themselves portable homes using small stones and other objects. This one lives in fast streams.

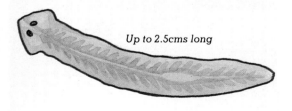

Up to 2.5cms long

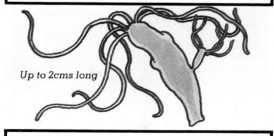

Up to 2cms long

Flatworms glide smoothly over mud, stones, plants and under the surface film of the water. They eat living or dead animals.

Hydra, related to the sea anemone, captures small animals like the water flea. Look for it on the leaves of water plants.

An aquarium at home

Many of the small animals that you find in ponds and streams can be kept in a fish tank at home, and you will have lots of fun watching them if you set up your aquarium properly. You can buy plastic or glass fish tanks quite cheaply from most pet shops. Then all you have to do is follow the steps below to arrange the contents.

Remember that your aquarium will need a certain amount of light, but don't stand it in the full sun. This could make the water too hot for the animals, and will also encourage the growth of green algae on the sides of the tank so you won't be able to see what's going on inside! A cover is not really necessary unless you want to keep things like water beetles which can fly away. Whatever you do, it is a good plan to put the tank in position before you fill it, because a tank full of water is very heavy!

1 Put a layer of clean gravel in the bottom of your tank and arrange a few natural stones on it. *Don't* use pieces of concrete, though, and avoid stones with sharp edges.

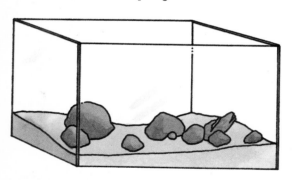

2 Get some plants from a pet shop or from a friend's garden pond. But never take them from the wild without the pond owner's permission. Plant them in your tank by pushing their bases into the gravel or under the stones. Arrange them in small clumps, not in rows.

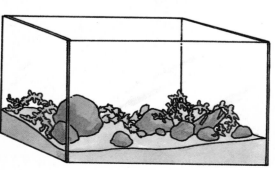

3 Cover the gravel and plants with sheets of newspaper. You can then pour in clean pond water without disturbing the bottom of the tank. Remove the paper when the tank is full.

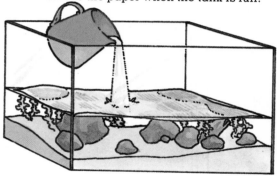

4 Don't put any animals in your aquarium for a week or so. This gives the plants time to settle down. If the bottom gets too dirty, usually because you have too many animals, you can syphon the dirt out with a plastic tube: keep the end which is outside the tank below the inside end.

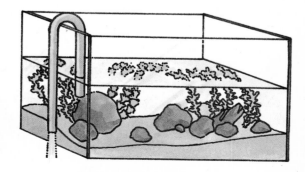

Plants for your aquarium

If you buy plants for your aquarium, make sure you get *cold water* types. Some useful ones are shown here.

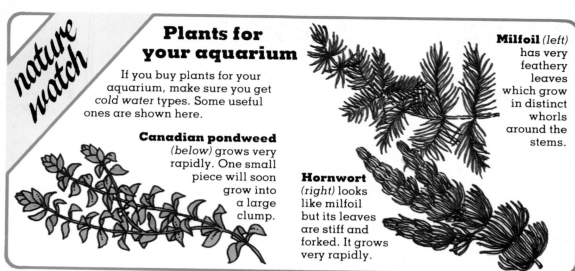

Milfoil (*left*) has very feathery leaves which grow in distinct whorls around the stems.

Canadian pondweed (*below*) grows very rapidly. One small piece will soon grow into a large clump.

Hornwort (*right*) looks like milfoil but its leaves are stiff and forked. It grows very rapidly.

5 Your finished aquarium can contain small fish as well as many other creatures, although the fish might well eat some of your smaller "pets". Give them a feast of water fleas from time to time to keep them happy. You can get these from pet shops in a dried form, often under the name of daphnia. Alternatively, you can collect some live ones from a pond. You could also add a couple of ram's-horn snails and perhaps a freshwater mussel (see page 28). Caddis larvae (page 11) are interesting, and so are freshwater shrimps and water slaters. The latter look rather like woodlice and will help to keep your aquarium clean by eating the debris that collects on the bottom. You can find these small animals in the mud or under stones at the bottom of ponds or streams. Small water beetles and water boatmen are also fun to watch, but don't put great diving beetles (page 41) or young dragonflies (page 34) in with your other creatures: they would very soon eat them all up! Finally, make sure you have plenty of plants to keep the water well supplied with oxygen.

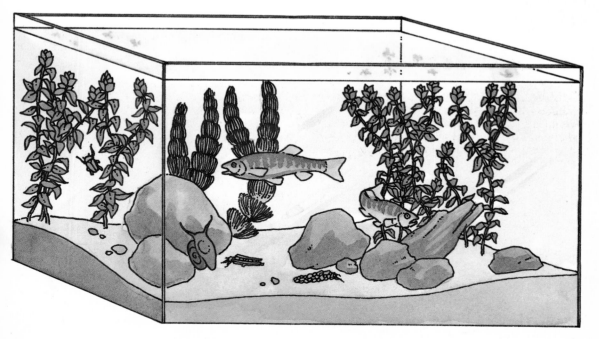

The patient fisherman

The heron is one of nature's most patient fishermen. It spends hours standing quite still at the edge of a pond or stream, just waiting for a fish to swim by. Then, when it spots a suitable victim, it makes a lightning lunge with its long neck and grabs the unfortunate fish firmly in its great, pointed beak. In a flash, the heron throws back its head and swallows its prey in one big gulp! But the heron's patience does not last for ever – its fishy food does not always come along on time, and then the heron has to go looking for it instead. Wading in the shallow water, as you can see in the picture, the heron slowly puts one foot in front of the other and keeps a careful watch for any fish or other animal that it disturbs. Eels are among its favourite foods, but it will eat any kind of fish that it can catch. It also eats frogs, small grass snakes, water voles and even young ducklings.

Herons don't mind being watched as long as you don't get too close. So it is usually best to use binoculars. If you do disturb the birds they will leap into the air and flap slowly away on their great black-tipped wings. They keep their necks bent when flying, by pulling the head right back to the shoulders, as you can see on the left of the picture. This is one good way of telling them apart from storks and cranes, which fly with their necks outstretched.

You might expect these large birds to nest on the ground, perhaps among the waterside plants, but strangely enough they usually make their nests high in the trees. Often forming large colonies, they build their nests with twigs and generally use the same ones year after year. The nests get larger and larger as time goes by and often look very untidy. Three to five eggs are laid early in spring and the baby herons spend nearly seven weeks in the nest before they fly away.

nature watch

Topsy-turvy flamingoes

The flamingo is surely one of the world's strangest birds. It likes to live and feed standing around in muddy water, but its long spindly legs help ensure that its beautiful pink feathers never get dirty. It goes to sleep standing up, too – and on only one leg! But its broad webbed feet anchor it firmly and prevent it from falling over. It also has a very unusual beak which is designed especially for straining small animals from the water. It holds its head completely upside-down when feeding and sweeps its beak to and fro to collect any food stirred up by its feet. Have a good look at these strange birds when you next visit a zoo. And if you're ever lucky enough to visit the Carmargue area of southern France, keep your eyes open for the wild flamingoes that live there. Notice how they fly in flocks with their long necks outstretched.

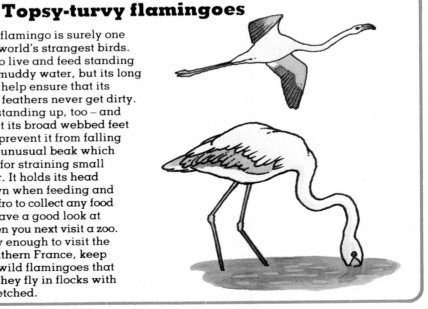

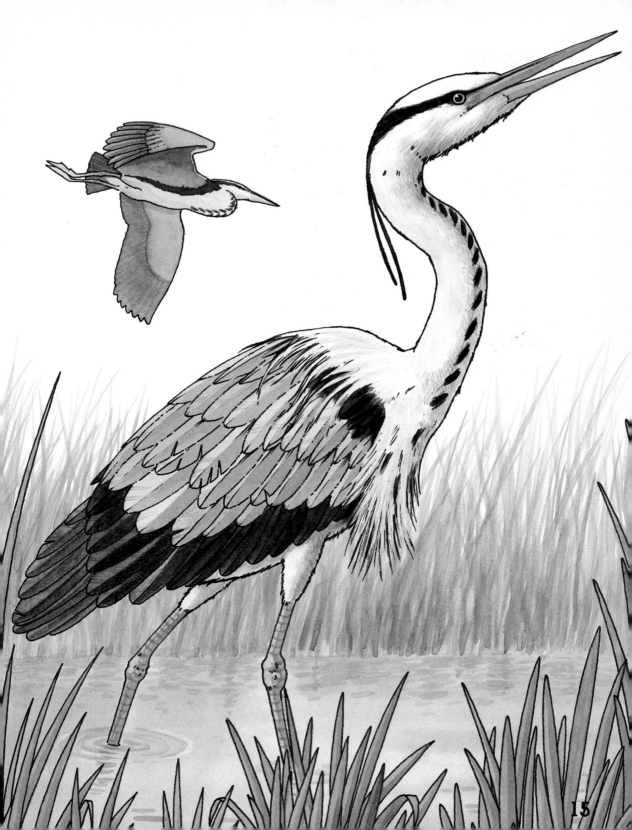

Prickly sticklebacks

Sit by almost any clean pond or small stream and you will probably see some small fish darting from one clump of weed to the next. See if you can catch some in a net and then tip them into a dish or jam jar full of water. The chances are that your fish will be three-spined sticklebacks like those in the big picture. Look for the three sharp spines on their backs which give these fish their name. The male, at the top of the picture, is in his spring breeding colours. At other times of the year he looks like the female beneath him, although perhaps not quite so plump. He is about 8 cms long.

You shouldn't keep your sticklebacks in the jam jar for too long, but if you have an aquarium at home (see page 12) you can take them back with you and keep them there. Then you can watch their under-water antics more easily. Make sure that they have plenty of water weeds. And feed them regularly with small numbers of water fleas and other tiny creatures, such as mosquito larvae (see page 11). Watch the fish dart after their prey and suck it into their mouths. If they suck in something that doesn't taste very nice they'll quickly spit it out again!

Very few fish make nests for their eggs and babies. But sticklebacks do, and it is the male who does all the

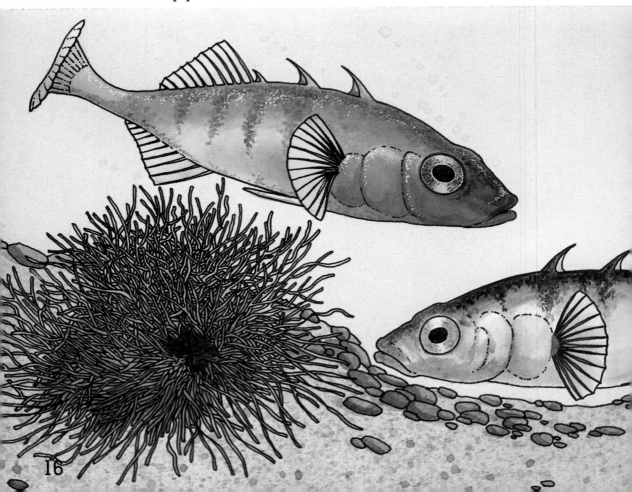

16

building. He starts by scraping a small hollow in the stream bed, and then makes a tunnel-like nest over it by gluing bits of water weed together. He fights off other males, but when a female approaches he will start to dance around her, fanning his tail and proudly displaying his red breast. In this way he gradually leads her to his nest where she lays her eggs. But as soon as she's finished he chases her away and guards the nest himself! The eggs hatch after a week or two, but the babies stay in or around the nest for a further week. If they stray too far, their father darts out to catch them and carries them back to the nest in his mouth. You might even be able to watch this happening if you keep some sticklebacks in your own aquarium.

nature watch

Who's in the mirror?

In the breeding season male sticklebacks are very jealous of each other and will attack strangers that come near their nests. You can see this for yourself if you put a small mirror in your aquarium with a male stickleback. The fish will be fooled into attacking his own reflection. He raises his spines when angry.

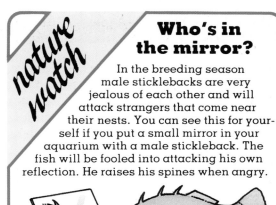

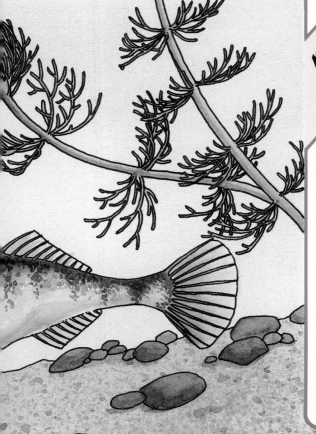

nature detective

More tiddlers

The three-spined stickleback is by no means the only "tiddler" to be found in our ponds and streams. How many others can you catch in your net? Let them go when you have looked at them.

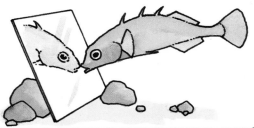

Up to 7cms long

The **nine-spined stickleback** (above) is not as common as its three-spined cousin, but you will find it in weedy ponds and streams. It fixes its nest to the weeds.

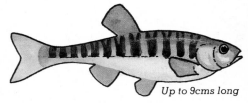

Up to 9cms long

This male **minnow** (above) is in his breeding dress. At other times his belly is silvery, like the female. Minnows live in fast-flowing streams with sandy or stony bottoms.

The playful otter

You have probably never seen an otter outside a zoo. But if you have ever watched one in such a place then you will know what a wonderful swimmer this creature is. Using its powerful tail and webbed feet, the otter drives itself through the water with amazing agility, almost as if it's swimming and diving only for fun. But playing like this is actually good training for hunting, so the hungry otter doesn't usually have much trouble in catching a fish for its dinner. The otter in the picture has caught a trout, but eels are really its favourite food. As well as fish, the otter will also eat frogs and young water birds. It hunts almost entirely by night, and sometimes wanders far from the water. In fact, young otters have been known to travel many miles overland in search of new homes.

Otter babies are born in burrows in the river bank. There are usually two or three in a family and they start swimming when they're about ten weeks old. They love to slide down muddy banks into the water, and both the youngsters and their parents also seem to enjoy "tobogganing" down snowy slopes in winter. The babies are looked after entirely by their mother and stay with her until they are about a year old.

Otters were once quite common in and around our lakes and rivers, but they are now rare in most parts of Europe. Water pollution and an increasing number of motor boats cruising up and down the rivers has taken its toll of these graceful creatures. Nowadays, you will have to look for them on undisturbed stretches of river or on the wilder parts of the coast. Strong-smelling droppings full of fish scales might give you a clue to their presence. They leave these around the boundaries of their territory, warning other otters to keep away.

nature detective

Otter look-alikes

The muskrat and the coypu are sometimes mistaken for the otter when they are swimming with just their heads above the water. They are much smaller than the otter, though, and look quite a different shape when they're on dry land! Both these creatures are vegetarians belonging to the group of mammals that we call *rodents*. And both were brought to Europe from America for their fur. They used to be reared on special farms, but many escaped and now live in the wild. The muskrat is common in many parts of Europe, but it is not found here in Britain. You can identify it by its tail, which is strongly flattened from side to side.

The coypu's strongholds are the marshlands of the Norfolk Broads in England and the Carmargue of southern France, although it also occurs elsewhere in smaller numbers. Look for both these creatures around lakes and rivers where there is plenty of vegetation.

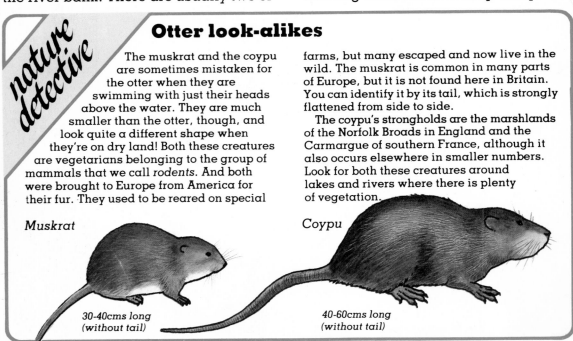

Muskrat

30-40cms long (without tail)

Coypu

40-60cms long (without tail)

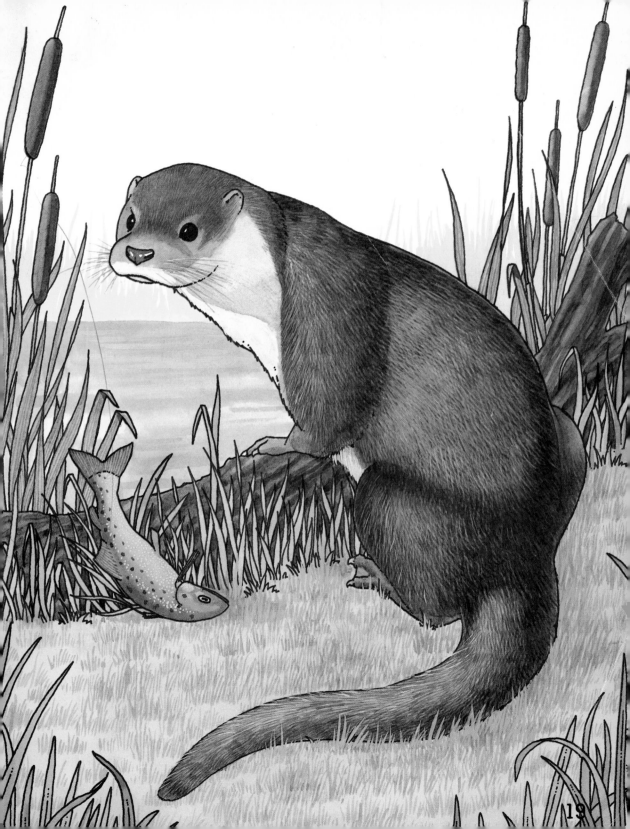

Come dance with me!

If you visit a lake or river on a warm evening in spring or summer you might well see swarms of insects dancing up and down over the waterside plants. Try to get close to a swarm. You will probably find that the insects are mayflies, rather like the one on the left of the picture. There are many different kinds of mayfly. Most have clear, colourless wings, and all of them have two or three long tails. Some kinds prefer to hold their dances over the water instead of the plants, and often the dances go on for hours and hours. In fact, the dancers are almost all male mayflies, and the aim of

their dance is to attract the females. When a female approaches the swarm she is quickly grabbed by a male and the pair then dance off together to mate.

After mating, the female lays her eggs either in or on the water. The young mayflies aren't much like their parents apart from their three long tails – they have no wings to speak of and they crawl around in the water instead of flying about in the air. Moreover, they eat tiny plants and animals, whereas their parents don't eat anything at all! These youngsters take one or two years to grow up, then they swim to the surface and turn into the adult insects. They

don't live very long once out of the water, though – sometimes for just a few hours, although some may last as long as a week. They are called mayflies because they are particularly common in May, but you can actually find them all through the summer.

Not all dancing swarms consist of mayflies. Many are formed by gnats, and others by caddis flies like the insect on the right of the picture. The caddis fly has much longer antennae and, unlike the mayfly, it can wrap its wings around its body, as you can see below. Look very carefully at a caddis fly and you will see that its wings are clothed with tiny hairs. There are lots of different kinds of caddis fly and many fly by night.

A case for the caddis

Young caddis flies live in the water, just like mayfly youngsters, and feed on small plants and animals. But the unusual thing about them is that most kinds build portable cases around themselves. They use sticky silk from their own bodies to make the case and glue small stones or plant fragments to it. Then, as the grub grows, it adds more "bricks" to the front end of the case, arranging them very neatly with its legs and jaws. The cases are usually tubular and open at both ends, but otherwise each species has its own design. You can see some at the bottom of the page.

Scoop up some mud or gravel from a pond or stream and put it in a dish of water. You will soon spot the caddis cases. Occupied ones will start to move about and you should put all these living caddis grubs back into the pond or stream once you have looked at them. Many of the cases will be empty, however, because the insects have grown up and left. Make a collection of these empty cases. Try to find out whether pond-living caddis grubs use different materials from stream dwellers. How many different building materials can you find? Instead of making portable cases, some caddis grubs make silk webs or pouches among the water plants. Life is easy then, because food becomes trapped in the webbing.

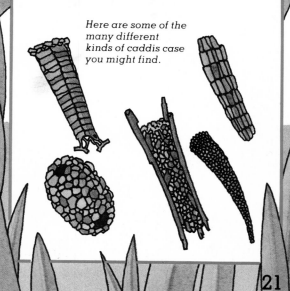

Here are some of the many different kinds of caddis case you might find.

21

Diving for dinner

A flash of brilliant blue is all that most people ever see of the kingfisher. But if you know where to look, you can often see a lot more of this beautiful bird. Quiet pools and small streams are the ideal spots. A local bird-watcher might be able to tell you exactly where to look.

The kingfisher usually has a favourite perch where it sits and watches the water. The perch may be a waterside fence or post, but it is more likely to be a tree branch over-hanging the water. At first sight, you might think the bird is sleeping, so still does it sit, but all the while its beady eyes are on the look-out for fish in the water below. When one comes close to the surface the kingfisher is off like a bullet! With its wings swept right back, as you can see on the right of the picture, this daring diver plunges into the water and then actually swims underwater after its dinner! If it's lucky, the kingfisher catches the fish in its large beak and then flies straight back to its perch. Everything happens so quickly that the whole thing is over in about a second. Try to time it if you can find the kingfisher's perch. You'll find that the bird will make lots of dives, but will not always manage to catch a fish. Sticklebacks and minnows are its main food. You might see the bird bashing them on its perch to kill them before they are eaten. They may be thrown in the air and then swallowed head-first!

Kingfishers nest in burrows which they dig into the riverbank (as you can see in the circle). The parents have about six babies and have to catch many fish to feed their large family.

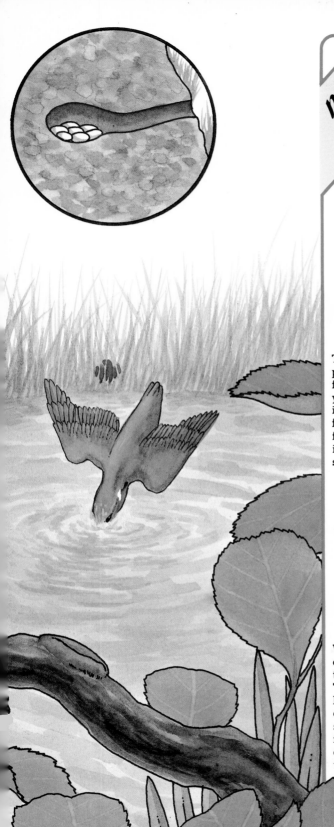

Taking a dip

If you take a walk by a stony upland stream, you might well see a small brown and white bird bobbing up and down on the stones. This is the **dipper**. It gets its name because of its bobbing action, but it also takes a dip in other ways!

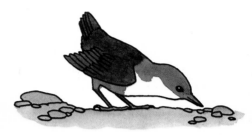

The dipper gets some of its food while paddling in the shallows, but most of its feeding is done right under the water. Use your binoculars to see the bird wade in until it is completely submerged. It prefers fast-flowing streams because this is where it can find the most freshwater shrimps, which are its favourite food. It also eats worms, insects, snails, and even young fish.

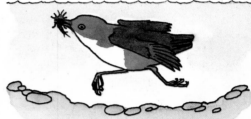

When under the water the dipper may run along the stream bed, but more often it "flies" through the water by flapping its wings. Thick, oily feathers keep its body dry. Dippers have been known to take as many as 1600 dips in a day! Each dip lasts for 4-5 seconds, and most dips result in a beakful of food. Look carefully with your binoculars and you might see the food in its beak when the bird surfaces.

23

A croaking chorus

Have you ever heard frogs in the breeding season? They are very noisy animals indeed. From February onwards the males gather in shallow ponds and make their croaking sounds. They croak all day *and* all night, as long as it is not too cold. When there are dozens of them all croaking together the noise sounds like a lot of motor bikes roaring along in the distance. In fact, in some warmer countries the frogs make so much noise that it is difficult for people to get to sleep!

The males don't croak just for the sake of it, though. They do it to attract the females to the ponds, where they mate and then lay their eggs. Frogs, together with toads and newts (see page 30), belong to the group of animals called amphibians. This name means "double life", for all of them spend part of their lives in the water and part on the land.

There are many different kinds of frog. The one in the big picture is known as the common frog, and it is the only one you are likely to see in most parts of Britain. Its colour ranges from dirty green to brick red, but you can always identify it by the dark stripe running across the side of its face. It usually lives in damp places on the land, except during the spring breeding season, and you may even find it in your garden. This frog feeds on worms, slugs and many other small animals. Its long back legs are used for leaping, as well as for swimming when in the water. During the winter the frog goes into a deep sleep, usually hidden away in the mud at the bottom of ponds and ditches.

Frogs are not as common as they used to be because there are fewer ponds in which they can breed. Make a pond in your garden (see page 32) to help these fascinating animals.

nature watch

A frog grows up

Frogs and toads spend their early lives in the water in the form of tadpoles. But, as they grow, they undergo a remarkable change. You can watch these changes take place by studying your local pond, or you can collect a small amount of spawn (eggs) and put it into your garden pond or aquarium. Use your *Nature Diary* to record when the eggs hatch and to note down all the other changes that you see. The tadpoles will nibble water plants at first but later on you should give them *small* pieces of meat.

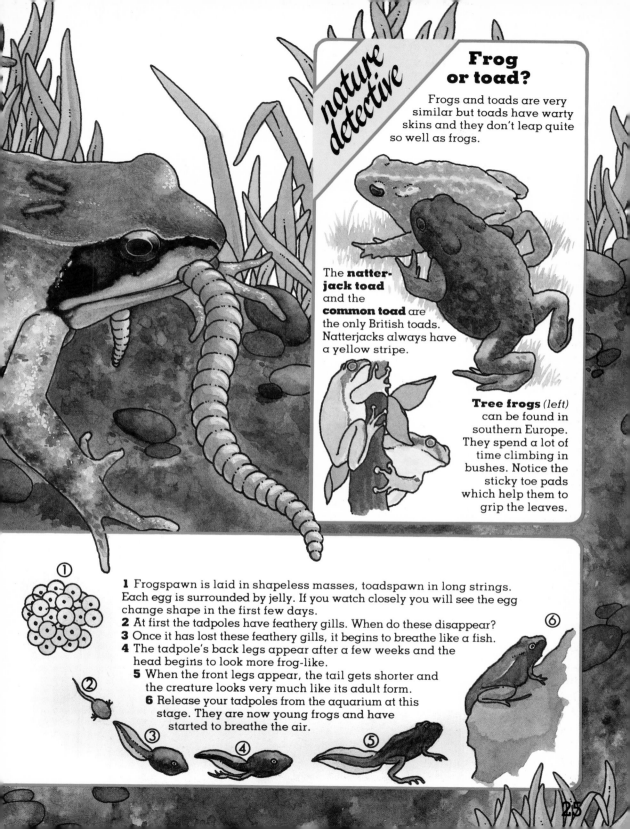

Frog or toad?

Frogs and toads are very similar but toads have warty skins and they don't leap quite so well as frogs.

The **natter-jack toad** and the **common toad** are the only British toads. Natterjacks always have a yellow stripe.

Tree frogs (left) can be found in southern Europe. They spend a lot of time climbing in bushes. Notice the sticky toe pads which help them to grip the leaves.

1 Frogspawn is laid in shapeless masses, toadspawn in long strings. Each egg is surrounded by jelly. If you watch closely you will see the egg change shape in the first few days.

2 At first the tadpoles have feathery gills. When do these disappear?

3 Once it has lost these feathery gills, it begins to breathe like a fish.

4 The tadpole's back legs appear after a few weeks and the head begins to look more frog-like.

5 When the front legs appear, the tail gets shorter and the creature looks very much like its adult form.

6 Release your tadpoles from the aquarium at this stage. They are now young frogs and have started to breathe the air.

25

Hiding in the reeds

If you hear a loud *kuruk-kuruk-kuruk* coming from the reeds by a pond or river, it means there is a moorhen about. Keep quiet and you might see this bird emerge and swim jerkily across the water. Notice its red beak and forehead and prominent white tail feathers. You might think at first glance that the moorhen is a duck, but you'd be wrong. Look at the ducks on page 38 and you will see that they have broad, flat beaks. The moorhen's beak is quite different. Can you spot any other differences? Watch out for the moorhen's footprints in the mud at the edge of the pond or stream, (you can see what they look like from the drawing below).

Moorhens feed mainly on waterweeds. They sometimes up-end themselves like dabbling ducks, but at other times they dive right to the bottom of the pond in their search for food. They also graze on young cereals in the fields, and enjoy foraging for grain after the harvest, sometimes travelling quite a long way from the water. They need a long take-off run in order to get air-borne, though. Watch them running across the water surface, rapidly flapping their wings.

The moorhen's nest is made from a large pile of plant debris. It's usually built among the reeds but sometimes the parent birds will make it on a small island in the middle of a pond. About ten eggs are laid and incubated by the parents. The two birds in the picture are about to change places at the nest. The chicks are black and fluffy and can swim soon after hatching.

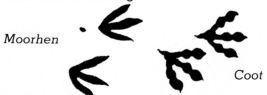

Moorhen

Coot

nature detective

More water birds

Use your binoculars to watch water birds on lakes and rivers. Many of them are shy and will dash for the reeds if they see you getting too close, so it is a good idea to hide behind a tree trunk or a clump of reeds or bushes. Use your *Nature Diary* to record when and where you discover the various different kinds. At what time of year do they have babies with them? Be a nature detective and look for the different footprints in the mud at the water's edge. Some are shown on the left.

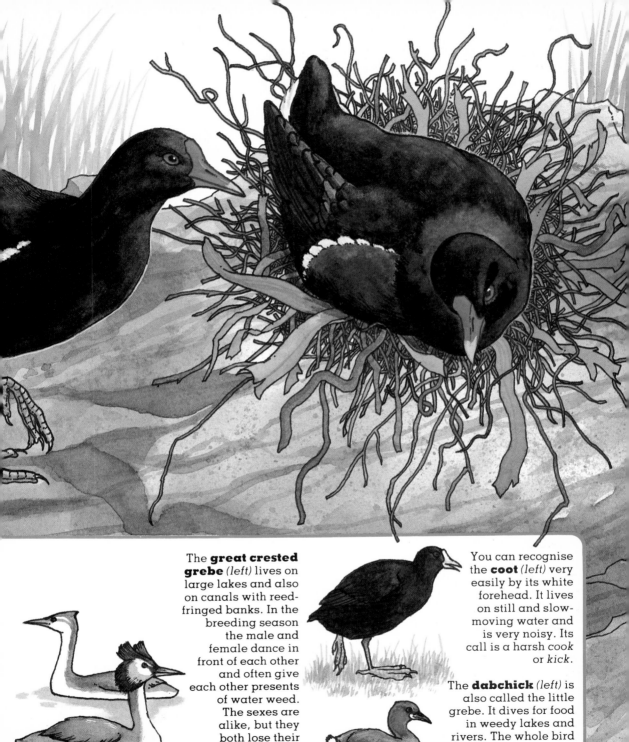

The **great crested grebe** *(left)* lives on large lakes and also on canals with reed-fringed banks. In the breeding season the male and female dance in front of each other and often give each other presents of water weed. The sexes are alike, but they both lose their colourful head feathers in winter.

You can recognise the **coot** *(left)* very easily by its white forehead. It lives on still and slow-moving water and is very noisy. Its call is a harsh *cook* or *kick*.

The **dabchick** *(left)* is also called the little grebe. It dives for food in weedy lakes and rivers. The whole bird becomes greyish for the winter.

Slow-moving snails

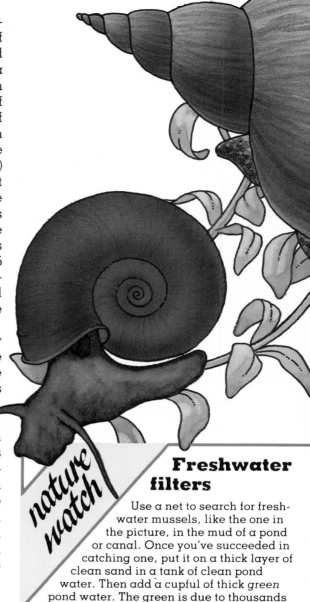

Most ponds have at least some inhabitants that you can be almost certain of catching. And all you have to do to find them is drag some water plants from a weed-filled pond and examine them in a jam jar or pie dish. (A good way of getting the plants is to tie a couple of strong wire hooks to the end of a length of string. Throw the hooks among the weeds and then haul them in again.) When you examine them, you will almost certainly see some water snails like those in the picture. The large one on the right is the great pond snail, whose shell may be as much as 5 cms long. The other one is the ram's-horn, whose shell may be 2.5 cms across. Look also for the snails' jelly-like egg masses. Those of the pond snail are sausage-shaped, while those of the ram's-horn are more or less circular.

Using the muscles in their broad, slimy foot, the snails glide slowly over the water plants searching for food. Like the snails in our gardens, they have tongues like tiny strips of sandpaper which they use to rasp food from the weeds. The pond snail chews up whole leaves and often attacks other animals as well. But the ram's-horn prefers to scrape the fluffy green algae from plants and stones. This is one reason why the ram's-horn is a good snail to have in your aquarium, since it will help to keep the glass clean. If you watch it through the sides you will see the tongue busily scraping away the algae.

If you watch the snails for a while you will see that they surface periodically to release a bubble of stale air. They take fresh air in before going down again. The ram's-horns don't come up very often. Try to find out why. It has something to do with the red colouring in their bodies.

nature watch

Freshwater filters

Use a net to search for freshwater mussels, like the one in the picture, in the mud of a pond or canal. Once you've succeeded in catching one, put it on a thick layer of clean sand in a tank of clean pond water. Then add a cupful of thick *green* pond water. The green is due to thousands of microscopic plants called algae. The mussel will filter these from the water and eat them. How long does it take your mussel to clear the water? Put the mussel back in its pond after your experiment.

A breath of fresh air

The ancestors of the great pond snail once lived on the land, many millions of years ago, and this is why the animal still has to breathe air like you and I. It can absorb some oxygen from the water through its skin, but it can't get enough by this method alone, so from time to time it has to gulp air down into its single lung. Much of the oxygen in the water comes from the water plants. Carry out the following simple experiment to see how much difference the plants make.

1 Put five or six great pond snails in an aquarium tank or a plastic lunch box filled with pond water and plenty of water weeds. Watch carefully for at least an hour and count the total number of visits the snails make to the surface to renew their air supplies. They probably will not make many such visits because the plants give off plenty of oxygen in the daytime. When your snails come to the surface, look for the lung opening near the lip of the shell.

2 Transfer the snails to a similar container with similar pond water but no water plants. Count the number of surface visits over the same length of time. There will be more, because the water contains less oxygen. Now put the snails into water that has been boiled to drive off all the oxygen: the snails will spend even more time at the surface. (Remember to cool the water first!)

The **swan mussel** (below) is our largest freshwater mussel. Notice the siphons which it uses to pump water in and out of its body.

Siphons

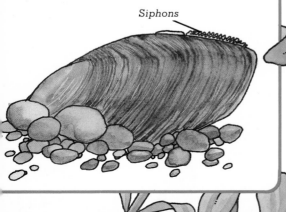

29

Wriggly newts

Newts are quite easy to find in the spring when, like the frogs and toads, they gather in the ponds to lay their eggs. Perhaps you get them in your local pond? If not, try to find some to keep in your aquarium for a little while. You can catch them with a small net, and they are fascinating to watch. Try to get a male and a female and give them a few *small* worms to eat.

The black newt at the top of the picture is a female great crested newt. The others are smooth newts, the commonest of the three kinds to be found in Britain. The male is the one with the brighter colours and the wavy crest on his back and tail. When courting, he dances round the female and quivers his tail to entice her. Try to watch this display in your pond or aquarium. You might even be lucky enough to see the female laying her jelly-wrapped eggs on the water plants and folding the leaves around them.

Remember to take your newts back to where you found them when you have finished watching. Take the eggs as well, or else put them into your garden pond. It is not easy to keep baby newts in an aquarium because they need lots of minute animals to eat.

After the breeding season the male newt loses his fine crest and both sexes leave the water. They spend the rest of the year in damp ditches and similar places, living on small insects and worms. People finding newts on land often think that they are lizards, but they have much softer skins than lizards and no scales. Like the frogs and toads, the newts go to sleep for the winter, hiding under rocks or in the rubbish at the bottom of ditches.

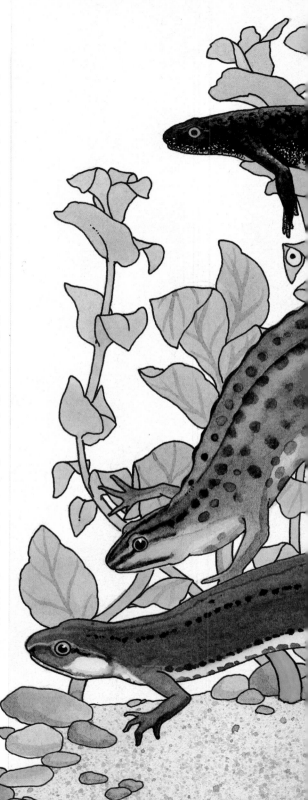

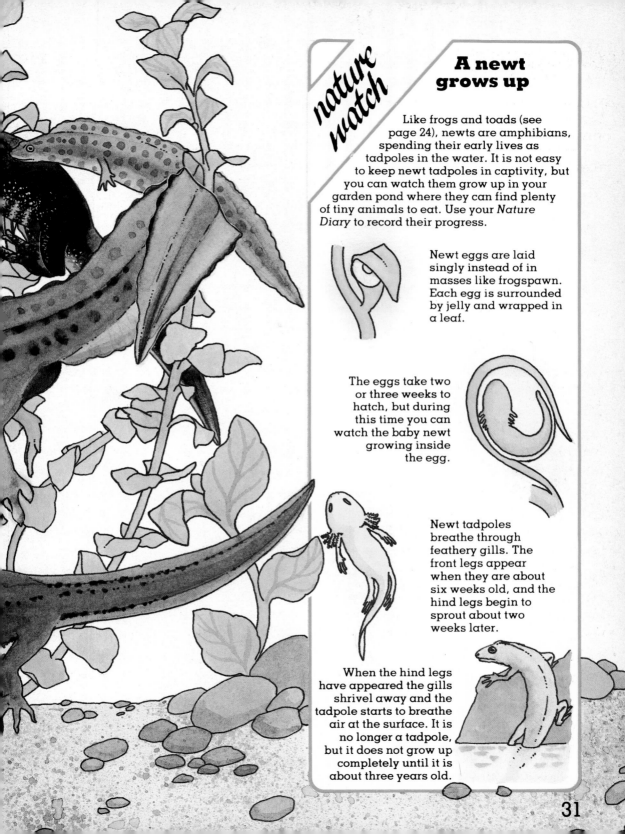

A newt grows up

Like frogs and toads (see page 24), newts are amphibians, spending their early lives as tadpoles in the water. It is not easy to keep newt tadpoles in captivity, but you can watch them grow up in your garden pond where they can find plenty of tiny animals to eat. Use your *Nature Diary* to record their progress.

Newt eggs are laid singly instead of in masses like frogspawn. Each egg is surrounded by jelly and wrapped in a leaf.

The eggs take two or three weeks to hatch, but during this time you can watch the baby newt growing inside the egg.

Newt tadpoles breathe through feathery gills. The front legs appear when they are about six weeks old, and the hind legs begin to sprout about two weeks later.

When the hind legs have appeared the gills shrivel away and the tadpole starts to breathe air at the surface. It is no longer a tadpole, but it does not grow up completely until it is about three years old.

31

A pond in your garden

Garden ponds are very popular. You can get a lot of fun out of watching the various animals that live in the pond or visit it to feed and drink. The pond is also an important breeding place for frogs and newts (see page 24 and 30). And since many farm and village ponds have disappeared in recent years, these fascinating animals are relying more and more on garden ponds. If you don't have a pond already perhaps you could persuade your parents to help you make one in the garden. With the right kinds of plants in and around it, the pond can be a very attractive feature. And it need not involve a great deal of work.

The easiest way to make a garden pond is to buy a ready-made fibre-glass

1 Choose a fairly sunny site for your pond. Don't dig it under trees, because the shade will not let the plants grow properly and the pond will fill up with dead leaves in the autumn. The hole for your pond should be at least 50 cms deep in the middle with shallower areas around the edge. The shelves need not all be of the same depth. If your pond is less than 50 cms deep in the centre your animals could die in a hard winter when the ice gets thick. However, 50 cms down they will be protected from the worst of the cold.

Shelves

2 Line the hole with a layer of soft peat or sand, or even with a layer of old newspapers. This will prevent any sharp stones in the soil damaging the liner. You are now ready to lay the pond liner over the hole.

Layer of sand

3 Having stretched the liner over the hole, mould it roughly to shape. Make sure that there is plenty of overlap around the edges. You can start putting the water in at this stage.

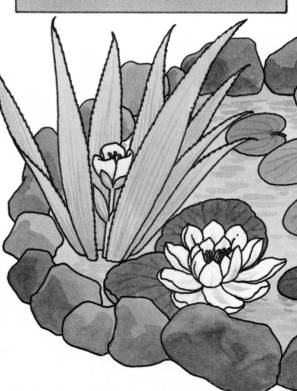
Liner

one. You can get these in a wide range of shapes and sizes, and all you have to do is dig a hole of the right shape, drop the pond in and fill it with water. A slightly more complicated method is to use a flexible liner (either thick black polythene or a specially made pond liner), as shown in the diagrams below. The advantage of this method is that the liner stretches and moulds itself to any shape you like.

You can lay turf right up to the water's edge to make your pond look natural, but crazy paving also looks very nice and you won't wear it away if you keep walking round your pond.

Frogs and newts may arrive of their own accord to lay their eggs in your pond in the spring, and many water-loving insects will fly to your pond in the summer. Keep a diary to record all the newcomers. You can, of course, add fish if you like, but they will eat your tadpoles and other small creatures.

4 Lay the turves or stones roughly around the edges to hold the liner in place. You can cement the stones in place later. See how the water moulds the liner to the shape of the pond.

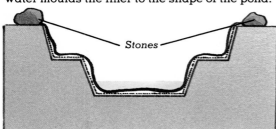
Stones

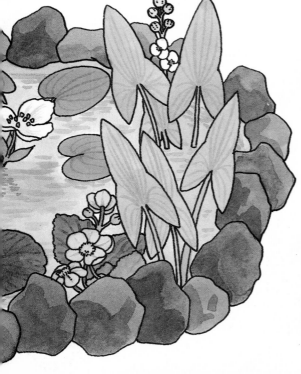

5 You are now ready to add the water plants. Water lilies, rooted in pots of soil, should go in the deepest area. Bulrushes, yellow flags, and arrowhead (see page 6) should be planted in pots on the shelves, where their bases will just be covered by the water. Then you can add some free-floating plants like Canadian pondweed, hornwort and water soldier. Beware of the latter's spiky leaves.

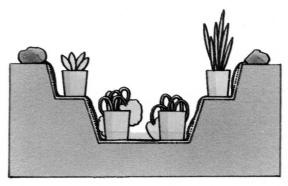

6 Finish filling the pond with water, but don't add any fish or other creatures for a week or two. This will allow the plants to get established. Add a few litres of water from another pond to build up the population of small creatures.

Dazzling dragonflies

Many people are afraid of dragonflies, even though they are quite beautiful insects. In fact, these dazzling creatures are even called horse-stingers in some places, but they are actually quite harmless. There are many different kinds. The one shown here is an emperor dragonfly.

Look for dragonflies flying over ponds and rivers in summer. If you concentrate on just one insect, you might well see that it flies to and fro over a particular stretch of water. This is its territory, and when it gets to the boundary it will stop and hover in mid-air before turning back. This behaviour is called hawking and it goes on for hours! Watch carefully and you will see that the dragonfly also darts sideways from time to time to snatch up a small fly in its bristly legs. It will eat its catch as it flies along. Notice too, the dragonfly's huge eyes, which help it to spot its tiny prey in mid-air. You might also see a dragonfly fight if one enters another's territory. The intruder will be attacked and chased away. The two may even collide, with much rustling of wings.

Not all dragonflies are hawkers, though. Some are known as darters. They spend most of their time sitting on a twig or reed, just darting out when they see a passing fly. If you look at the reeds around a pond you may also see some much smaller dragonflies with very slender bodies. These are called damselflies and they're not as good at flying as their bigger relatives. So they pluck small insects from the plants instead of catching them in mid-air.

During courtship the male dragonfly uses the claspers on his tail to hold the female by the neck. You can often see him towing her along. He may even lower her gently into the water as she lays her eggs.

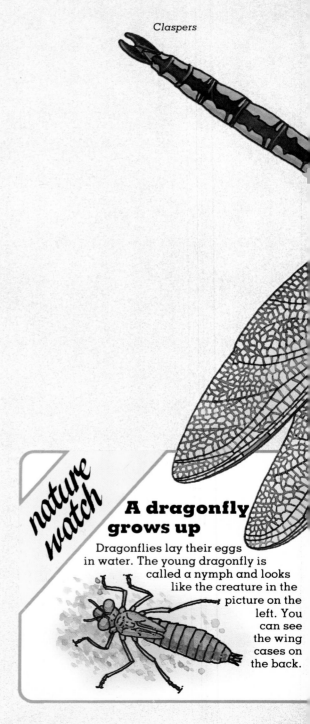

Claspers

nature watch

A dragonfly grows up

Dragonflies lay their eggs in water. The young dragonfly is called a nymph and looks like the creature in the picture on the left. You can see the wing cases on the back.

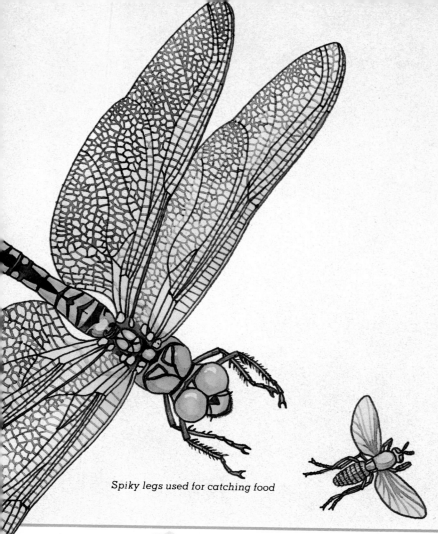

Spiky legs used for catching food

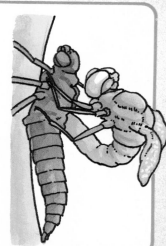

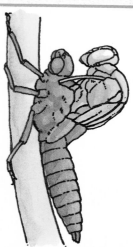

The nymph of a large dragonfly, like the emperor, may take five years to grow up. Smaller dragonflies may take only one year. The nymphs change their skins several times, and when fully grown they crawl up reed stems and leave the water, just like the one on the right. After a short rest on the reed, the nymph's skin splits along the back and an amazing change begins to take place. The adult dragonfly slowly drags itself out of the old nymph skin, and its crumpled wings begin to spread. It has to rest for an hour or two while its new body dries and hardens, and then it can fly away.

A toothy torpedo

The pike is the fiercest of our freshwater fish. So fierce, in fact, that it is sometimes called the freshwater shark. It can reach a length of about 150 cms and a weight of about 25 kg which is probably why it is the one fish that anglers love to tell stories about! You can see from the picture below that it has a slender, torpedo-shaped body and a huge mouth, bristling with sharp, backward-pointing teeth.

The pike lives in lakes, canals and slow-moving rivers, usually where there are plenty of water weeds. It spends most of its time resting quietly near to the bottom, hidden by the underwater plants. The stripes on its greenish-brown body camouflage it very well. So well, in fact,

that other animals are usually quite unaware that the pike is lurking nearby. But the pike is most certainly aware of them! It can pick up the slightest vibration in the water and it also has very good eyesight. So, when a suitable victim comes along, the hungry pike gives a couple of quick flicks with its powerful tail and shoots forward at high speed to make its catch. It can cover 10 metres in a flash, so you can see that its prey has very little chance of escape.

Other fish are the pike's main food. And it will even catch pike almost as big as itself. It can swallow such huge meals because its mouth opens so wide and its stomach stretches so amazingly that it

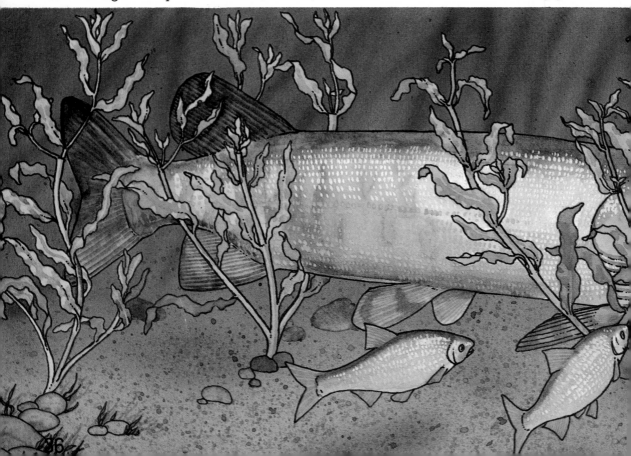

can easily fit them all in! Water voles, frogs, even ducks and moorhens are also caught and eaten by this ferocious hunter. But the pike doesn't spend all its time hunting and eating. After a large meal, it becomes very lazy and may spend ten days or more resting on the bottom, taking no notice of passing fish or the angler's bait. Many anglers like to try to catch the pike. In fact, they even have competitions to see who can catch the biggest one! Try to find out what sort of hooks they use.

Pike breed in the spring, laying their eggs on plants in shallow water. The baby pike eat water fleas and other small animals at first and take at least three years to grow up. Perhaps one reason why they sometimes grow so big is that, unlike most other fish, they can live for as long as 25 years!

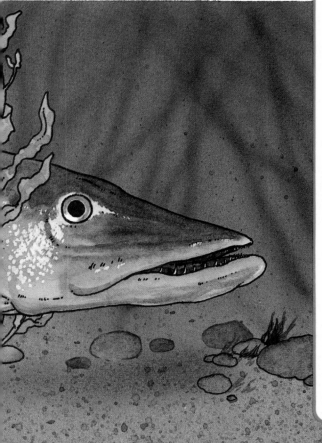

nature detective

The fisher-man's catch

If you watch people fishing on the river bank you might see them catch some of these fish.

Up to 50 cms long

The **perch** (above) can be recognised by its stripes and the very spiny fin on its back. It lives in lowland lakes and rivers.

Up to 50 cms long (usually much less)

The **roach** (above) is one of the commonest fish in lakes and slow-moving rivers, often living in large shoals.

Up to 20 cms long

The **gudgeon** (above) occurs mainly in rivers. It prefers clear water with a sandy bottom. Notice the two sensory barbels around its mouth.

Up to 50 cms long

The **tench** (above) is a slimy, bottom-living fish found in still and slow-moving water. It can stay alive for a long time out of water.

Dabbling and diving ducks

Go and have a look at your local pond. You are almost sure to see some ducks there, even if the pond is in the middle of town. Most of the ducks will probably be mallards, like those in the picture below. You can find these pretty birds on almost any kind of slow-moving or still water. Watch them feeding. They belong to a group known as *dabbling ducks*, which feed either by putting just their heads under the water or by completely up-ending themselves so that only their tails are left sticking up above the surface. Like most ducks, they feed on water plants and any small animals they can find in the mud. They also eat grass from riverbanks and, as you probably

know, they are fond of bread and grain! They spend a lot of time resting on the banks, and nest in nearby undergrowth.

The other main group of ducks are the *diving ducks*, which dive right under the water in search of food. You can also tell them from dabblers by the way they take-off in flight. Whereas the dabblers leap straight up from the water, the diving ducks need a take-off run and make a big splash as they rush along the water surface. They also spend much less time on the banks than the dabbling ducks. Use your binoculars and a good guide book to help you to identify the ducks you see on ponds and rivers. Some are shown on the opposite page.

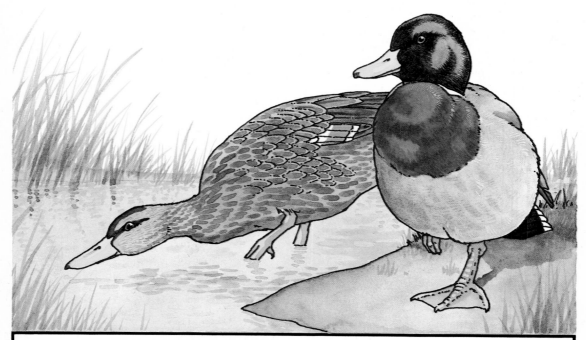

The male **mallard**, known as the drake, is more colourful than his mate. She is brown, like many other ducks, but you can always recognise her by the blue patch on her side. The male also has this. He loses much of his colour for a while in late summer, but always keeps the blue patch. You can tell him from the female at this time of year by looking for his yellow beak. Notice the large webbed feet which drive the birds quickly through the water.

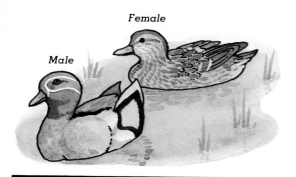

Female

Male

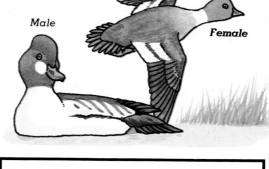

Male

Female

The **teal** is a dabbler, and also the smallest duck in Britain. The colourful male is easy to recognise. Look for the green patch on the side of the female. This duck likes lakes and rivers with dense vegetation around them.

The **goldeneye** is a diving duck which breeds in the far north and comes south for winter. Its head is almost triangular, and is brown in the female, green in the male. Look for the broad white wing patch in flight.

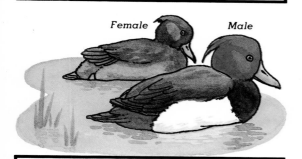

Female

Male

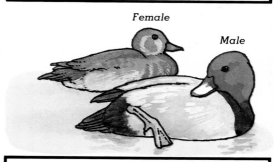

Female

Male

The **tufted duck** is a diving duck. The drake has white sides and a purply-black head with a long tuft of feathers on top. The female has only a short tuft. Like the pochard, this duck likes reed-fringed lakes.

The **pochard** is a diving duck. You can tell the male or drake by his chestnut coloured head, but the female is less easy to recognise: look for her brown neck and greyish brown body.

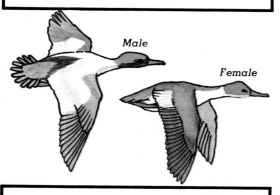

Male

Female

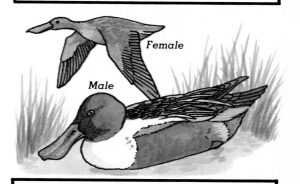

Female

Male

The **goosander** is a diving duck which specialises in catching fish with its saw-edged beak. Look for it on fast-flowing rivers as well as on lakes. The male is the one with the green head.

The **shoveler** is very easy to recognise because of its shovel-shaped beak and blue wing stripe. It is a dabbler, found mainly on weedy and muddy water. As with most ducks, the male is more colourful.

Walking on water

The animal in the big picture is a pond skater. It is one of several kinds of insect that live on the water surface, held up by what appears to be an invisible skin. If you look closely, you'll see that each of its legs rests in a tiny dimple in the water. If it's a sunny day, you'll probably find the skaters basking in a patch of sunlight. And sometimes the sun will glint from the dimples so the insects look as if they are surrounded by minute bright lights! Don't let your shadow fall on them when watching, though, or they'll skate rapidly away.

Pond skaters belong to a large group of insects called bugs, which all have a needle-like beak through which they feed. The pond skater catches its dinner of flies and other small insects by just waiting for them to fall on to the water surface. The skater can then detect the ripples made by its struggling prey and streaks across the surface to catch it. It is propelled along mainly by its middle legs, which row it across the water, while tufts of hair at the tips of the legs keep them from piercing the "skin". The hind legs act like rudders to steer the insect, and the front ones are used to catch the prey. Having caught its meal, the skater sucks out the juices with its beak.

You can see from the picture that the skater has large wings as well as long legs, so it is a good flier too. You might find one suddenly appearing on your garden pond or even struggling on a car roof, having mistaken the shiny surface for a small pond! However, not all pond skaters can fly: many have short wings or no wings at all. But, despite this, all the skaters leave their homes on the water in autumn and spend the winter asleep in clumps of grass, often far from their ponds and ditches.

nature detective

Beetles and bugs

Look for these common water creatures next time you visit a pond. Can you spot the main differences between the bugs and the beetles? Look at the wings!

Whirligig beetles (left) whizz round and round on the surface of ponds and slow streams, pushing themselves along with their broad, hairy legs.

40

Float a needle

Pond skaters can stay on top of the water surface because all water acts as if it is covered with an elastic "skin". As long as the insects don't break this skin they can stay on top of the pond. Try this simple experiment and you will see how this skin can hold things up.

1 Put a needle on a thin piece of tissue and lay it on the surface of some water in a dish.

2 The tissue will soak up some of the water and sink, but the needle floats on the surface – held up by the water's "skin".

3 Look very carefully at the needle and you will see it lying in a minute hollow – as if it is stretching the surface.

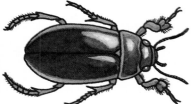

The great diving beetle *(above)* is a fierce predator. It catches and eats a wide range of animals, and will even attack frogs and fish. Watch how it comes to the surface to renew its air supplies. It carries its air under its tough front wings.

The **water scorpion** *(below)* is a flat bug which lives in shallow, muddy water. It catches other animals in its strong front legs and breathes by pushing its hollow "tail" up to the surface.

The **backswimmer** *(above)* is a bug which actually swims upside-down on its back, using its long back legs to "row" itself through the water. It feeds on other animals. It comes to the surface tail-first to renew its air supplies.

Picture index

Aquarium 12,13
Arrowhead 7

Backswimmer 41
Beetle
 great diving 41

 whirligig 40
Bewick's swan 8
Blood-worm 11
Branched bur-reed 7
Bulrush 4,7

Caddis fly 21
 case 11,21
 larva 11
Canadian pondweed 13

Common frog 24,25
Common toad 25
Coot 27
Coypu 18
Cygnet 9

Dabchick 27
Dipper 23
Dragonfly 34,35
 emperor 34,35
 nymph 34,35

Emperor dragonfly 34,35

Flamingo 14

Flatworm 11
Freshwater mussel 29
Frog 5
 common 24,25
 tadpole 25
 tree 25
Frogspawn 25

Garden pond 32,33
Goldeneye 39

Goosander 39
Great crested grebe 27
Great crested newt 30,31
Great diving beetle 41
Great pond snail 29
Gudgeon 37

Heron 4,15
Hornwort 13
Hydra 11

Indian balsam 7

Kingcup 6
Kingfisher 4,22,23

Larva
 caddis fly 11
 mosquito 11
 phantom 11
Leech 11

Lesser pond sedge 7

Mallard 38
Marsh marigold 4,6
Mayfly 5,20
Milfoil 13
Minnow 17
Monkey flower 6
Moorhen 26,27
Mosquito larva 11
Muskrat 18
Mute swan 9

Natterjack toad 25
Newt
 great crested 30,31
 smooth 30,31
 tadpole 31

**Nine-spined
 stickleback** 17
Nymph
 dragonfly 34,35

Otter 19

Perch 37

42

Phantom larva 11
Pike 36,37
Pochard 39

Pond 32, 33
Pond skater 40,41
Purple loosestrife 7

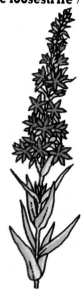

Ram's-horn snail 28
Reedmace 7
Roach 37

Shoveler 39
Smooth newt 30,31
Snail
 great pond 29
 ram's-horn 28
Stickleback
 nine-spined 17
 three-spined 16,17
Swan
 Bewick's 8
 mute 9
 whooper 8
Swan mussel 29

Tadpole
 frog 25

 newt 31
Teal 39
Tench 37

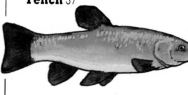

Three-spined stickleback 16,17
Toad
 common 25

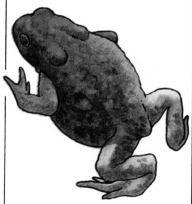

 natterjack 25
Tree frog 25
Trout 19
Tufted duck 39

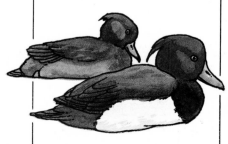

Waterfall 5
Water flea 11

Water lily 4,5
 yellow 6
Water scorpion 41

Whirligig beetle 40

Whooper swan 8

Yellow wagtail 4
Yellow water lily 6

Panel index

A breath of fresh air 29
A case for the caddis 21
A dragonfly grows up 34
A frog grows up 24
A newt grows up 31
Beetles and bugs 40
Dipping into a pond 10
Float a needle 41
Freshwater filters 28
Frog or toad? 25
More tiddlers 17
More water birds 26
Otter look-alikes 18
Plants for your aquarium 13
Pond or lake? 5
Taking a dip 23
The fisherman's catch 37
Topsy-turvy flamingoes 14
What is a waterfall? 5
Who's in the mirror? 17
Winter swans 8